NEW
JERSEY
HESSIANS

NEW JERSEY HESSIANS

Truth and Lore in the American Revolution

PETER T. LUBRECHT

THE
History
PRESS

Published by The History Press
Charleston, SC
www.historypress.net

Front cover, clockwise from upper left: National Museum in Warsaw; National Museum in Warsaw; Museum of Hesse; Museo Nacional de La Habana, public domain; National Portrait Gallery, London; unknown location, public domain.
Back cover: photo courtesy of the author; insert: Museum Boijmans Van Beuningen Rotterdam, public domain.

First published 2016

Manufactured in the United States

ISBN 978.1.46711.810.1

Library of Congress Control Number: 2016937193

For Jack, Michael and James

CONTENTS

CONTENTS

Preface

Ihave heard the word "Hessian" from grade school through high school. Until my interest in American history became a passion, I paid little attention to the German troops that fought for the British during the American Revolution. After I moved out of New York City, I discovered that I had been living in the midst of Manhattan Island's Hessian fortifications, taken from the American army early in the War for Independence, when General Washington's forces retreated north and across the Hudson River to Fort Lee, New Jersey.

As kids we rode our sleds down Fort George Hill; we took the bus over Kingsbridge Road to the Bronx (formerly Bronk's Farm) and visited the Cloisters on Fort Washington Avenue. My family lived on Dongan Place, named after the fifth colonial governor of New York. I walked to school on Arden Street, named for butcher and Revolutionary War private Jacob Arden. I crossed Sherman Avenue, named for the family that lived on a little creek just off the Harlem River, then made a left on Sickles Street, which was named either for the infamous Union general Dan Sickles or for Zachariah Sickels, who arrived in New Harlem in 1693. I then reached Nagle Avenue, named for a Dutch soldier who bought land there. The whole neighborhood was in the middle of the "Dyckman Valley," named after Jan Dyckman, whose descendants were Patriots in the middle of Loyalist New York.

Even in an era when American history was an ongoing lesson presented to immigrant and first-generation students, I had no concept of the details of the war that brought my own country to independence. We knew of George Washington and the redcoats, as well as the Boston Tea Party and Paul Revere's ride. There were no films or TV specials (there was no television early in my life). However, my history teachers at the Bronx High School

of Science, Mrs. Isabel Schoenfeld, Miss Doris Eliason and Mr. Arthur Merovick, lit the fire of historical curiosity that still burns today. They took us from the path of popularized Hollywood heroic sagas to the pages of the original documents of American history. However, I still had no idea of the details concerning the combatants on both sides of the conflict.

Perhaps the omission of German soldiers' place in history, on both sides of the war, was connected to the time during which I grew up. Postwar Inwood housed so many German Jewish refugees from the Holocaust that it was called "Frankfurt on the Hudson" or the "Fourth Reich." In those years, the Germans were the "bad guys." The surrounding community of Irish, Jewish and German immigrants knew my family as "righteous gentiles." War veterans, many badly maimed, were part of our lives, so it is little wonder that pieces of history were glossed over and often ignored.

Every boy with "lead soldiers," as they were called then, had a collection of "Hessians," with red coats and brass hats. These, along with the "redcoats," were the villains. We were told that they were mercenaries, paid to fight against freedom here in the American colonies. Actually, they had a camp during the Revolutionary War between 204th and 214th Streets on Payson Avenue in Upper Manhattan.

During later years, a fascination with family history and genealogy related to American and German history led to my curiosity about the strange German mercenaries in the "tin hats" who came with the British during the Revolution. The "Sleepy Hollow" movies and films jogged me into the research path that I am now on. The revisionist history bug led me to Germany, where I visited the towns that housed the German troops imported to America. Although the truth of stories will continue to be argued, the legends that remain behind their journey, battles and, for some, their settlement in a new country can be examined, hopefully successfully, in the light of modern evidence.

I have had support on this project from a lot of people and organizations. Special thanks go to the archivists in Wolfenbüttel and Braunschweig, Germany, and also to the Auswanderer Museum in Bremerhaven for help in finding departure ports for the Hessian troops. Dr. Theodore Pearlman, my ophthalmologist, gave me the book *Hessian View of America* by Ernest Kipping, and this provided the impetus for this book. Thank you to Professor Fred Ulfers of New York University's German department; to Tom Dunn, an archivist at the Mahwah Museum in Mahwah, New Jersey; and to all my friends at Germania Park for the Germanic input, especially Henry Froelich and Teddy Lohrig for dialectal input. Lastly, I have to thank my family for putting up with this writing of books, and especially my wife, Thea, for all her patience and editing.

INTRODUCTION

Revolutionary literature teems with the testimony as to the courtesy and good breeding of the German officers, and numerous instances could be given going to show that they often endeared themselves to the people that they were here ostensibly to subdue.
—*Frank John Urquhart,* A History of the City of Newark, *Vol. 2*[1]

The tracking of Hessian legends was a journey almost equal to the one that the soldiers from Germany took during the American Revolution. It was hoped that research would find history of the travels and travails of the Hessian and other German soldiers as they came to the colonies, while avoiding the popular myths and images of them. The journey started with an article by historical reporter Jenny Sweetman in the *New Jersey Herald,*[2] "County Resident Plans to Write a Book about Hessians." This article would hopefully lead to local information and connections to historical societies in New Jersey. Several local stories surfaced. But the problem with Revolutionary War literature concerning the Hessians is that it is spread across two continents in three different languages. When printed out, the "finding aid" for the New York–New Jersey area measures two inches thick—and that is only for the known and digitalized documents. Letters and documents from the period can be found across three states in different societies and libraries. Research proved difficult and finally focused on one area of the Hessians of the Revolutionary War: the truth about these soldiers.

The next step began in Bremerhaven, Germany, supposedly the port from which the German troops left their home country. A discussion with the curator of the new Auswanderer Museum in Bremerhaven provided the

information that many of the troops left from Bremen Vegesack, one hour to the east near the Weser River. Vestiges of the old harbor remain, and the museum had some material on the Hessian troops' departure. The research trip in this world, taken by Autobahn, was certainly quicker than the march of the earlier soldiers.

The next stop was Marburg and its castle overlooking the town of Hesse-Kassel. The magnificent great hall and the opulence of the building was striking. The museum houses souvenirs of the American colonies, the most interesting being a powder horn with scenes of the war carved on the outside. Hesse-Hanau still has the old timbered houses and a tribute to its most famous residents, the brothers Grimm. From there, the journey led to local archives in the tiny town of Wolfenbüttel, home of the Brunswick general Friedrich von Riedesel. The duke of Brunswick lived in a castle in Braunschweig close to a massive *schloss* almost completely destroyed during World War II but lovingly restored to contain a museum, the archives, a Starbucks and a shopping mall. The archivists were phenomenal in their knowledge of the troops and the generals. They produced neatly wrapped documents, many original, including drawings and insignia from the American Revolution. The only problem for the researcher is the absence of English in these beautiful facilities.

Modern farmers whose ancestors lived in New Jersey since before the Revolutionary War tell stories of kind soldiers or of ravaging, beastly men who attacked women and children. They are aware of the presence of the troops, but their locating them in time and place is mostly vague. There is talk of "Hessian" strongholds, ghosts and deserters—much of it apocryphal. But their information is a starting point. A search for the sources of these stories led to historical societies in New Jersey. That was the good news; the bad news was that most of the local records were not digitalized or catalogued.

The stateside research tour began with over forty societies, libraries and collections in Sussex County, New Jersey. Other relevant museums and materials are housed across the state, from tip to tip. The challenge of finding new material was a real treat. Researchers find pleasure in unearthing new material, often with the knowledge that it is the first time it has been read in two hundred years or more.

An early researcher was William Stryker, the adjutant general of New Jersey. He was a Civil War general who compiled a list of Jerseymen in the Revolutionary and Civil Wars. He also found the German records of the Colonel Rall court-martial, held in Philadelphia, and had them translated into English by a German writer. The original handwritten

documents are in the New Jersey State Archives in Trenton. This led to a tour of the Trenton battlefield, clearly marked in the middle of a city that once was a small village.

Material about the iron forges and the Hessians is largely in the Morristown Library, much of it original and some in the old German script. The northern iron mines were in the Ramapo Mountains in Mahwah, New Jersey. The historical society there holds a large amount of material on the Ramapo Mountain people. The smaller societies and libraries had bits of information that became very useful. Each has a story to tell. There was so much information found in the state, including some yet untouched, that a book about troop movements and battlegrounds would fill several volumes. The letters and articles are there for further research. This research path ended with the idea that this book should concentrate on the history of the German soldiers' and rulers' contracts, journeys and the ensuing misconceptions and myths about their time in America.

1.

THE HESSIAN IMAGE

American schoolchildren are taught that the ragtag American Patriot armies in the Revolutionary War were fighting against professional red-coated British soldiers supported by well-trained, evil German mercenaries called "Hessians." When asked about these mercenaries, the average American will say that they were German soldiers hired to fight brave Continental forces. However, what is the truth? Were they all "mercenaries"? Were they all evil? Did the world wars in the twentieth century and the corresponding anti-German feelings influence the image and the truth of these eighteenth-century troops?

The word "Hessian" has become a general term for the military that fought in the American Revolution; however, the German armies, on both sides of the conflict, were from different states of the land that we now call modern Germany. The image of these troops, however, has been magnified, changed and popularized over the last two centuries. The use of the negative term "mercenary" was applied to these soldiers long before they came across the water to the colonies and was coupled with a negative view of German immigrants in the early years of settlement.

The German farmers, who came from the Palatine region of Germany and flooded Pennsylvania and the New Jersey hills, were uneducated peasants with craft and farming skills. They were clannish, as many immigrants were, and still are today, keeping largely to themselves without learning English. Because of the tremendous expense of traveling to the new land, and as a result of unscrupulous actions of "importers," many were sold on the

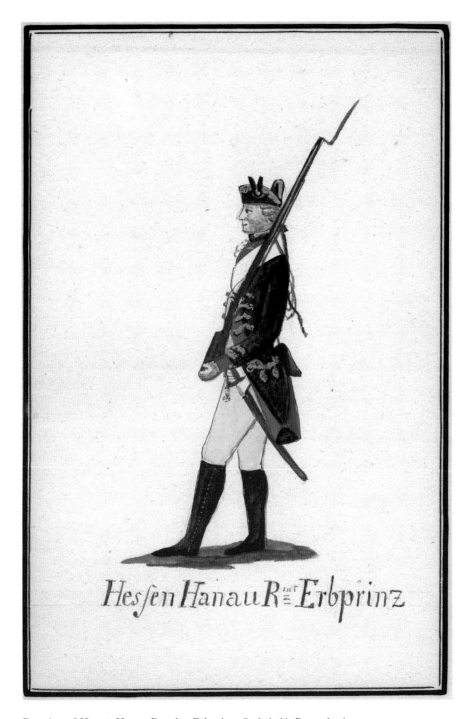

Drawing of Hessen Hanau Regular, Erbprinz. *Stadt Archiv Braunschweig.*

auction block as indentured servants and separated from relatives, taken into non–German speaking homes at a very young age. Their language sounded strange, guttural and unnatural to their fellow British colonists. Several early Americans, including Benjamin Franklin, had distaste for the Germans, which he expressed in a letter to Peter Collinson on May 9, 1753:

> *Those who come hither are generally of the most ignorant Stupid Sort of their own Nation, and as Ignorance is often attended with Credulity when Knavery would mislead it, and with Suspicion when Honesty would set it right; and as few of the English understand the German Language, and so cannot address them either from the Press or Pulpit, 'tis almost impossible to remove any prejudices they once entertain. Their own Clergy have very little influence over the people; who seem to take an uncommon pleasure in abusing and discharging the Minister on every trivial occasion. Not being used to Liberty, they know not how to make a modest use of it.* [3]

Franklin was not alone in his opinion of the Germans. During the French and Indian Wars, German settlers were recruited to the King's Royal Sixtieth Rifle Corps, and Germanic names are found on the list of lieutenants in it. George Faesch, Emanuel Hesse, Rudolphus Bentineck, Bernard Ratzer, Fred Weissenfels and the rest were all German immigrants. Their uniform had a round hat with a feather sticking straight up from it. That feather, and the unruly dress of the "bumpkin" colonial soldiers, led to the song "Yankee Doodle Dandy." It was originally written to make fun of the "uncultured" character of the farmer troops, who were so called because of their "crude" emulation of the eighteenth-century British dandies, self-styled fashion plates fresh from Italian travel.[4] This upper crust's love for macaroni, an Italian culinary delicacy to them, morphed into the fashionable term of being "very macaroni." The song made fun of the crude feather and the attempts to copy this fashionable style by the "vulgar peasant army." Ironically, the tune of the song was of German Hessian origin, and the lyrics were written as a mockery of crude non-English-speaking, bumpkin troops.

The German population, however, stayed aloof from other early Americans, clinging to its traditional clannishness. In later years, German immigrants brought an innate snobbery of all things German, considered superior to that of the "nouveau" culture of the colonies and, eventually, the United States. This attitude was echoed in the British view of ragged, uneducated and less-than-genteel citizens of the new country. This snobbery was carried into the twentieth century until both world wars brought a flood

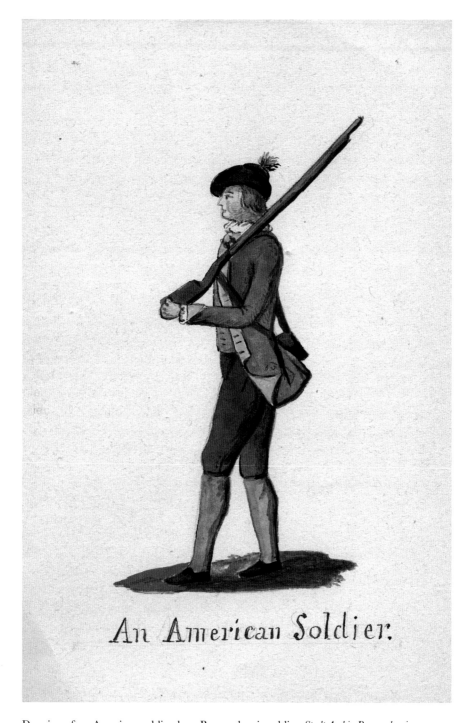

Drawing of an American soldier, by a Braunschweig soldier. *Stadt Archiv Braunschweig.*

of anti-German feeling, causing a submersion of cultural attachment in the German American community.

An even more ancient disdain for the idea of a "mercenary" was combined with the pre–Revolutionary War dislike for the "peasant" immigrant from the German states. Beginning in the first and second centuries, the Roman Empire used German soldiers recruited from newly conquered territories as a bodyguard regiment, or *Germani corporis custodes.* The Frisi and the Betasii, tribesmen from Batavi, in the Rhine Delta, were considered to be barbaric, pillaging marauders. Julius Caesar had a German bodyguard; however, it was the emperor Octavian who started the practice of hiring Germanic soldiers. The disdain for foreign troops on home soil spread throughout the Middle Ages. In the twelfth century, bands of *Routiers* (French) and *Rotten* (German) mercenary soldiers terrorized their nations' populations during the Hundred Years' War. The Swiss mercenaries, or *Reisläufer,* served in foreign armies. William Shakespeare refers to them as "Switzers" in act 4, scene 5 of *Hamlet.* When Claudius receives an intrusive messenger, Queen Gertrude asks, "Alacke, what noyse is this?" The angry king replies, "Where are my *Switzers?* Let them guard the doors."

The German emperor Maximillian formed the first "Landsknecht" regiments in 1487, as direct copies of the Swiss soldiers for hire. These troops developed into the prototype of the soldier for pay and often could be found facing each other during battle. Most of them came from Swabia, Alsace, the Tyrol and the Rhineland. They created the image of the "savage" mercenary soldier engaged to help fight against any enemy.

Machiavelli condemned the mercenary in his guide to political ascension *The Prince* (1513), as did Sir Walter Raleigh, one hundred years later, in his *History of the World* (1614). Machiavelli wrote:

> *Mercenaries are at once useless and dangerous, and he who holds his State by means of mercenary troops can never be solidly or securely seated. For such troops are disunited, ambitious, insubordinate, treacherous, insolent among friends, cowardly before foes, and without fear of God or faith with man. . . . I ought to have little difficulty in getting this believed, for the present ruin of Italy is due to no other cause then* [sic] *her having for many years trusted to mercenaries.*[5]

Early American settlers had experienced, or had heard of, the exploits of the "evil Mercenaries." The image of the German soldier preceded them into colonial America and was continually forged by contemporary legend,

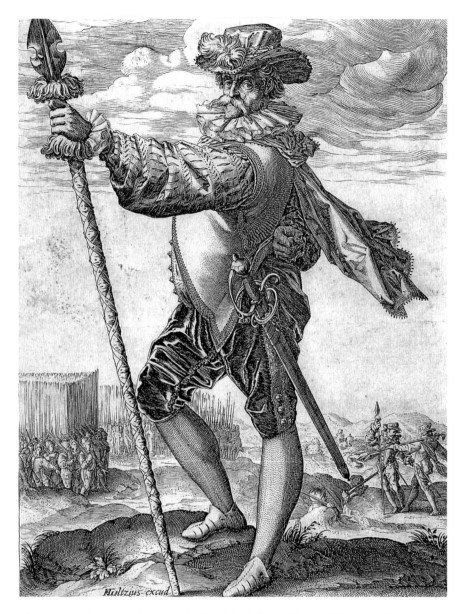

Mercenary of the sixteenth century, by Hendrik Goltzius. *Museum Boijmans Van Beuningen Rotterdam, public domain.*

stories and the media into the image of the "hired gun." Those who could read found accounts in the local newspapers several months after the event, including articles from abroad about the use of paid foreign armies on

native soil. News reached Philadelphia, New York and Boston regularly.[6] For example, the *Boston News Letter* of September 18, 1721, reported:

> *On Friday last there pass'd by here 500 Men of Hessian Troops for Pomerania; and we understand from Brunswick, that the like Number has march'd there, taken the same Rout. According to the Treaty made between the Kings of Great Britain and Sweden, and Landgrave of Hesse Cassel, a Camp of 12,000 Men is to be formed about Stralsund. We are inform'd, that Prince Mensikoff, with the Fleet from Cronslot and Revel is sailed to the Coast of Finland; so that we daily expect to hear of an Engagement at Sea.*[7]

The *American Weekly Mercury* of May 21, 1730,[8] reprinted an article from the *Daily Journal* (London) on the use of German troops as a standing army of twelve thousand Hessians for British defense. These articles are unclear about the financing of these troops; however, the term "mercenary" appears in several different articles. The adjective "foreign" is the most often used to describe the hired soldiers. They are also called "Haughty Mercenaries," "Janissary" (Turkish) or "dirty Mercenaries." By the mid-1700s, there was increasing activity of hired "Hessians." The September 26, 1745 *Pennsylvania Gazette* reported Hessian troops joining the Austrian army,[9] and the same newspaper reported on May 25, 1773, a translation of a letter from Berlin of December 3, 1772, announcing "warlike preparations of German Princes taking Hessian and Brunswick troops into pay."[10]

Obviously, rumors spread among those who were illiterate as well. Many of the northeastern colonists had experienced military might and oppression in

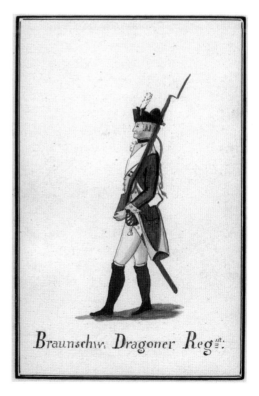

Drawing of a Braunschweiger Dragoner Regiment soldier. *Stadt Archiv Braunschweig.*

their homelands. Oral history in families can span at least two hundred years and sometimes even more. Family lore and legend is a record of genealogical experience, including stories and glimpses of events from memory and letters in the past: therefore, the farmers and artisans in colonial America had knowledge of foreign troops and of some of the evils of rape, pillage and destruction attached to them. The contemporary belief was that the rewards for the soldier were plundered souvenirs and permissible abuse of human existence.

During the American Revolution, the British and Hessian soldiers were guilty of destroying the lives and the properties of the colonists. The Declaration of Independence not only decried the importation of troops but also accused them of cruelty that was past those of "barbarous ages."

> *He is at this time transporting large Armies of foreign Mercenaries to compleat the works of death, desolation and tyranny, already begun with circumstances of Cruelty & perfidy scarcely paralleled in the most barbarous ages, and totally unworthy the Head of a civilized nation.*[11]

The evil image of the "Hessian Mercenaries" grew after the "American War" and continued in the early histories of the Revolution. It progressed through later textbooks so that the image of the Teutonic units became a legendary stereotype. There were three early histories of the American Revolution written by American authors: Mercy Otis Warren's *The History of the Rise, Progress, and Termination of the American Revolution* (published in 1805 in three volumes), David Ramsay's *The History of the American Revolution* and George Bancroft's *History of the United States from the Discovery of the American Continent*. The three authors treated the landing of the "Hessians" as an invasion by despicable and brutal army.

Warren's *History* is believed to be the first account of the Revolution written by an American author. She lived through the war in New Hampshire. Her writing depicted the Hessians as the worst offenders of the mistreatment of civilians by the royal army. Because the rewards of forfeited rebel estates were not forthcoming, the Hessians were let "loose" upon the occupied territories:

> *A considerable part of this army (British) was composed of discontented foreigners, who, disappointed of the easy settlements they had been led to expect, from their conquest of the rebels, and the forfeiture of their estates,—their former poverty not mitigated, nor their yoke of slavery meliorated, in the service of their new masters they,—they were clamorous*

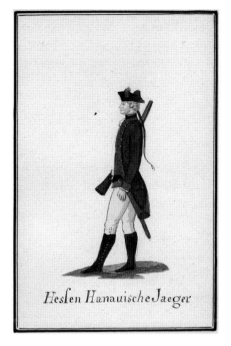
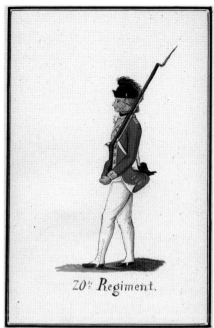

Left: Drawing of a Hessen Hanauische Jaeger soldier. *Stadt Archiv Braunschweig.*

Right: Drawing of a Twentieth Regiment soldier. *Stadt Archiv Braunschweig.*

for pay, and too eager for plunder, to be kept within the rules of discipline: and their alien language and manners disgusting to their British comrades, a constant bickering was kept between them.[12]

David Ramsay's version of history relates the march of the British and German armies through New Jersey and decries the violence and the brutal nature of the "Germans":

The soldiers of the royal army, and particularly the Hessians, gave full scope to the selfish and ferocious passions of human nature. A conquered country and submitting inhabitants presented easy plunder, equal to their unbounded rapacity. Infants, children, old men and women were stripped of their blankets and cloathing [sic]. Furniture was burnt or otherwise destroyed. Domestic animals were carried off, and the people robbed of their necessary household provisions. The rapes and brutalities committed on women, and even on very young girls, would shock the ears of modesty, if particularly recited. These violences were perpetrated on inhabitants who had

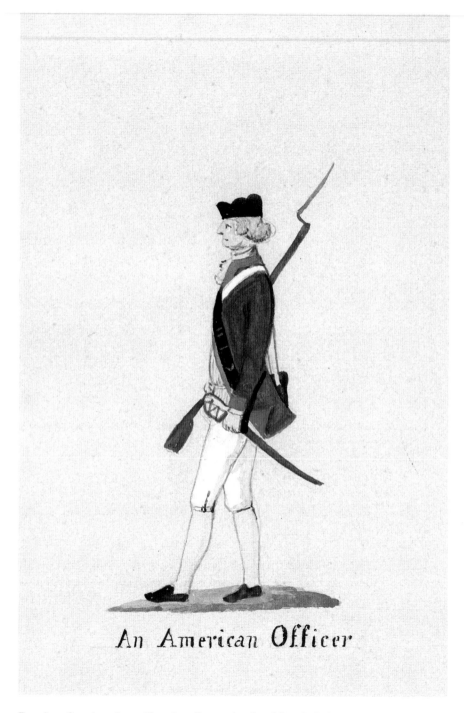

An American Officer

Drawing of an American officer, by a Braunschweig soldier. *Stadt Archiv Braunschweig.*

remained in their houses, and received printed protections, signed by the order of the commander and chief. It was in vain, that they produced these protections as a safeguard. The Hessians could not read them, and the British soldiers thought they were entitled to a share of the booty, equally with their foreign associates.[13]

Ramsay, an American physician who lived through the war, as did Warren, focused on the plunder and pillaging by the foreign and British armies and added the sensational description of the rape of young girls as another reason for hatred. The third American historian in the years following the conflict was George Bancroft, who was born after the Revolution and educated at Harvard. His claim to fame was the establishment of the U.S. Naval Academy, and although he studied extensively in Germany (meeting Goethe, Hegel and other leading scholars), his view is one of Romantic American nationalism, a heroically slanted history based on the success of the Patriots against all the odds and against the "evil nature" of the "foreign troops."

In an empire which spoke the language of Luther, where Kant by profound analysis, was compelling skepticism itself to bear witness to the eternal law of duty, where Lessing inculcated faith in an ever improving education of the race, the land of free cities and free thought, where the heart of the best palpitated with hope for the American cause, the landgrave forced the energies of his state to act against that liberty which was the child of the German forests, and the moral life of the Germanic nation. And did judgment slumber? Were the eyes of the Most High turned elsewhere? Or, in the abyss of the divine counsels, was some great benefit in preparation for lands all so full of tyrants, though beyond the discernment of the sordid princes, whose crimes were to promote the brotherhood of nations.[14]

A reviewer of his work in the *New York Times* of 1860 saw a flaw in his account of these foreign troops. Germany was not a unified country until 1871 and, at the time of the American Revolution, was composed of about three hundred sovereign states. The review criticizes Bancroft for this viewpoint:

Thus, in his account of Britain's engagement of foreign troops, (chap. lvii.) he falls into the gross error of confounding the state of things in Germany at the close of the Thirty Years' War, with the very different state of things in 1775![15]

Portrait of George Trevelyan. *New York Public Library, Tucker Collection.*

Sir George Otto Trevelyan, Second Baronet, was a civil servant in India who wrote *The American Revolution* (four volumes, 1903). The nephew of the noted historian Thomas Babington Macaulay (First Baron), he subscribed to his uncle's viewpoint of history, which divided the world into civilized people and the barbarians, with Great Britain as the apex and bastillion of class and education. Macaulay's works were more popular in America than in England, and his attitude of superiority carried over into Trevelyan's history:

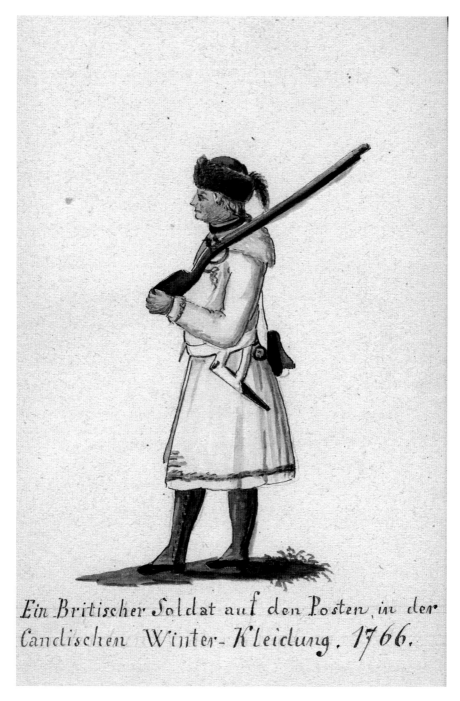

Ein Britischer Soldat auf den Posten in der Candischen Winter Kleidung 1766. (A British soldier in Canadian winter clothing, 1766.) *Stadt Archiv Braunschweig.*

> *Under the odious recruiting system that then prevailed in Central Europe, most German regiments comprised a dangerously large infusion of the refuse of the street and the sweepings of the jail. There were ruffians and vagabonds in the ranks whose presence as guests was a torment and terror to the quiet colonial households. America rang with the story of incidents that were maddening to a proud, a strict self-respecting people; whose home was their shrine; whose wives were their counsellors and true helpmates; and whose children were tenderly cherished, and carefully instructed in religion and at least the elements of learning, under a system of education which, rude and imperfect as compared with modern requirements was superior to anything then existing in the rural districts of most European Kingdoms.*[16]

His description of the occupation of New Jersey includes a comment by Sir Henry Clinton, who took over the British command in New Jersey:

> *"Unless," he wrote "we would refrain from plunder, we had no business to take up winter quarters in a district we wish to preserve loyal. The Hessians introduced it.*
>
> *That was a point that never has been disputed. Writers of all parties and of both nations, and eye witnesses of every profession and calling,—whether they wore a red coat, or buff and blue, or the drab of a Quaker, or the sombre garb of a clergyman,—united in maintaining that our foreign stipendaries were the earliest, and incomparably the most flagrant offenders against the dictates of honesty and compassion."*[17]

Trevelyan portrayed the Hessians and other German troops as plundering, evil mercenaries, and he exonerated the British army of any attachment to pillaging, rape and theft. He quoted Robert Morris, the American commissioner in France,

> *that British troops were restrained from pillage; but that the Hessians and other foreigners looked upon the plunder as the right of war, and indiscriminately robbed all civilians with whom they came in contact.*[18]

Images of the rampant German mercenaries were etched by early American and British fiction writers, whose works were widely read on both continents. Charles Brockden Brown, the American author who pioneered the gothic novel, used the ugly mercenary characterization in his novel *Ormond*. James Fenimore Cooper, in his description of one of Washington's spies in

his novel *The Spy*, continued this idea of the mercenary, as did George Gordon, Lord Byron, in *Don Juan*. This book of poetic narrative sold out its first edition on the initial day of release in 1821, but it was branded by critics as an immoral work. However, the epic satire, as Byron called it, surpassed the critics' view in popularity. Sir Walter Scott, in the adventure novels *Ivanhoe* and *Quentin Durward*, includes traveling mercenaries who offer service for gain. The writers of this period of Romanticism and revolution considered the fight-for-pay soldiers as larger-than-life heroes who fought for "truth and light," helping the downtrodden while often fighting against other hired soldiers of an evil enemy.

Drawing of a British Black Watch Scotch Regiment soldier, by a German soldier. *Stadt Archiv Braunschweig.*

The events and military descriptions of the early histories were echoed by later volumes. Even though there were accounts that did not support these theories, the damage to any vestige of Hessian honor had been done, at least for popular history. The image has been sustained and embellished, with few taking notice of primary sources. Histories and history books using secondary sources kept alive the image of the savage mercenary. Modern high school history books omit or gloss over the term "Hessian" in relation to the troops gathered to fight for the British. One secondary text does not mention the existence of any German soldiers.[19] The text *America: Pathways to the Present*[20] mentions Hessians once in reference to the Battle of Trenton, while *American Nation* states, "The King also hired Hessian troops from Germany to fight the colonists."[21] The other reference to them in the book is the following: "Dec 26th the Americans surprised the Hessian troops guarding Trenton and took most of them prisoner."[22]

Our Land, Our Time, a high school textbook by Joseph Conklin, describes the Battle of Trenton:

> *Washington chose Christmas night to strike; He guessed correctly that the Hessians would celebrate the holiday with plenty of drinking. Washington recrossed the Delaware; His tiny force marched nine miles to Trenton, and at dawn completely surprised the Hessians. Washington captured the whole garrison.*[23]

Was there room in the text for further reference? Or was anti-German feeling of World Wars I and II part of the coverage? Or was it just sloppy research? Were the colonial troops referred to as Americans in 1776, or were they still the "Continental Army"? The image of the evil mercenary soldier fighting with well-trained British units, outnumbering and stronger than the raggedy group of untrained colonists, is the one promulgated in movies and television.

The Hessian Image in Film

Hollywood filmmakers have not often utilized the colonial period for movies and videos, as they have with the nation's subsequent wars and conflicts; perhaps the market for "American" films is not universal. There have been twenty-six films produced about the American Revolution and colonial period, including the D.W. Griffith 1909 silent epic *1776, or the Hessian Renegades* and the Mel Gibson vehicle *The Patriot*. Griffith cast a young Mary Pickford in his movie about the American Revolution. In it, an American spy delivering a message to General Washington is shot and killed in his family's house by cruel Hessians, who also attempt to assault one of the pretty girls who live there. The "willing suspension of disbelief" was severely tested when Griffith put the beautiful Mary Pickford in a Hessian uniform to march back and forth, pretending to be a German sentry. The message to Washington ultimately gets through. Griffith's silent epic introduced the image of the evil, crude German soldier. The scowling, leering soldiers are after food and women in this classic silent film. One reviewer wrote:

> *The Hessians are cartoon-ish villain stereotypes who laugh uproariously when the spy is shot (in case we don't get it, one even munches on a snack while looking down at the dying man).*

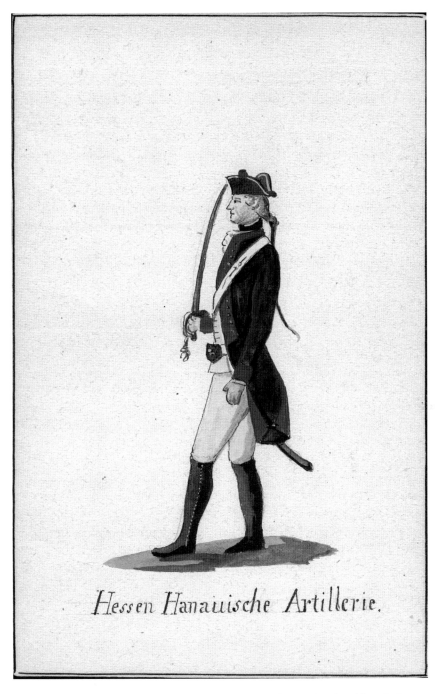

Drawing of a Hessen Hanauische Artillerie soldier, by a Braunschweig soldier. *Stadt Archiv Braunschweig.*

We learn little about our spy/hero in general, seeing him only in a few moments of desperation and exaggerated postures.[24]

The Warner Bros. cartoon "Bunker Hill Bunny"[25] has a Hessian opponent, Yosemite Sam von Schramm, in a fort attacked by Bugs Bunny at the Battle of Bagel Hill. Sam is short and angry and has the stereotypical "Hessian" grenadier hat as he battles with the clever bunny. Most movies use the same mitre cap as the mark of the Hessian soldiers, ignoring the fact that it was used in the British and Russian armies as well.

The Fox series *Sleepy Hollow*[26] rewrote the historical battles between the American Patriots and the Hessians. Ichabod Crane, in this version, is an American soldier who returns to Sleepy Hollow two hundred years after the war. He has been fighting the evil Hessian soldiers, including those who sold their soul to Moloch (a demon) and are tattooed with a Rheinhessen mark of evil. Ichabod fought against the Hessian Fifth Batallion and beheaded the famous horseman. The truth is that Rheinhessen is a Rhine wine, and the Fifth Batallion never existed. Artistic license allows the re-creation of history; however, in this case it projects the expected image of the evil mercenary.

When asked what they know about Hessians in the American Revolution, most people will answer "Germans" or "German mercenaries" or "I don't know." The only lasting image of these soldiers is one of "brass hatted giants" in red coats who raped, pillaged and plundered their way across America as hired hands of the British, who fought the outmanned Patriots.

2.

PAID MERCENARIES?

Mercenary, in the modern sense, denotes a soldier fighting for pay for a foreign government for personal gain. The German word for a true mercenary is *Söldner*, and the term for the armies that landed in Brooklyn with General Howe is *Soldatenhändel*, or rented soldiers. There were career soldiers in the German armies, choosing to fight as many did in earlier wars, but the foot soldiers were for the most part conscripted military men. Complete understanding of who they were can be found in the history of the country they came from and the leadership that caused the addition of Germans to the British army. The military and social playing field in what was then Germany was a crazy patchwork of land divisions, political conflict, high taxes and inbred nobility.

The study of the Germanic "playing field" during the mid-eighteenth century is a complicated maze of divided lands, despotic rulers and poverty. This history of Germany is fragmented, since the unified country as we know it today did not exist, but was compartmentalized into a series of separate and different kinds of governments. According to some writers, there were over three hundred sovereignties, each one maintaining a court and a militia.[27] Germany was divided into the larger Holy Roman Empire and also into smaller electorates, duchies, bishoprics and dominions of the margraves, landgraves, free cities and fourteen hundred estates of the Imperial Knights.

The most complicated administration of these realms was the Electorate, governed by prince electors, or *Kurfürst*, who were, in theory, the rulers who

Artillery

Drawing of an artillery soldier, by a Braunschweiger soldier. *Stadt Archiv Braunschweig.*

elected the emperor of the Holy Roman Empire in eighteenth-century Germany. Originally, in the thirteenth century, there were seven electors, including those of the church (archbishops of Mainz, Trier and Cologne) and four from the nobility (the king of Bohemia, the count palatine of the Rhine, the duke of Saxony and the margrave of Brandenburg). The duke of Bavaria replaced the count of Palatinate in the seventeenth century, and the duke of Brunswick-Luneburg became the elector of Hannover, which was eventually held by three British kings: George the I, II and III.

The secondary German nobility ruling smaller territories had no voting rights for the Holy Roman Empire. The prince bishops, who governed their regions, had the secular and clerical power only over the piece of land that they ruled. The landgraves, margraves, dukes and counts ruled a parcel of the land and used the revenues and taxes as they saw fit for personal use. A German landgrave *(landgraf)* had the same rank as a duke *(herzog)* but was above that of a count *(graf)*. Elected leaders from the various trade guilds governed independent free cities like Frankfurt, Hamburg, Reutlingen, Bremen and Cologne. Imperial Knights ruled fourteen hundred small kingdoms granted to them. They were dwarfed by the large German kingdoms of Prussia and Austria.

This complex geographical and societal structure left the common merchant and peasant, living on a subsistence level, just one means of escape from this overburdened life: join the military and fight either in Germany or take the chance of being sent to a foreign land. The landgraves and dukes had no problem conscripting men to the service. All of these soldiers were paid, and the duke was paid handsomely, to support his penchant for living in style.

3.

KINGS, PRINCES AND OTHERS

It is most probable that those who do not get their brains knocked out will insist upon staying among their own countrymen, who have emigrated there.
—Pennsylvania Evening Post, *June 13, 1776*

The rulers of the Grafschaften, Kreisen, Hertzogtümer, Wähler and Bistümer (counties, districts, duchies, electorates and bishoprics) were related to each other and also to King George III of Britain. Unraveling the relationships and intrigues is very difficult, particularly with arranged political marriages, countless infidelities and innumerable illegitimate children. Court intrigue and corruption were as much an interest to the public as they are in the modern world, where corruption on the highest levels of government is usually based on finance. The lands were overburdened by increasing taxes to pay for the extravagances of the nobility. One solution to the need for increased revenue was the sale of the homeland military forces.

There were a few precedents for "rented" militia" prior to and during the early eighteenth century. In 1647, 1,000 Hessians were "rented" to the Venetians fighting against the Turks, and in 1702, 9,000 soldiers from Hesse were serving English, Dutch and Austrians in the War of Spanish Succession. In 1706, 11,500 Hessians lost to the French army at the Battle of Castiglione in Italy. Throughout the eighteenth century, the English were the best customers. Soldiers were sent to Scotland to stop the "invasion" of Bonnie Prince Charlie; however, many refused to fight because of a lack of agreement on prisoner exchange. Some of them were present at the Battle

of Culloden in 1746 under the "Bloody Butcher," Prince William, the duke of Cumberland and King George II's youngest son.

The most extreme example of rented conscription was in 1743, when six thousand Hessians served in King George II's army and faced six thousand Hessians in the opposing force of Charles VII, at the Battle of Dettingen during the War of Austrian Succession. When the British monarch asked for aid from the Hessian and other German states, offering pay for troops to join the fight against the rebellious colonists, each ruler who "leased" his army for combat across the sea had different monetary and personal reasons for doing so. "Hessian" became the generic term for all of the soldiers from the various states.

The intermarriage of the nobles and royals, in an effort to keep the ruling lines "pure" and to continue the direct line of heredity ascension to the throne, influenced the connection between Britain and German states. Fifty-four-year-old George I of England was the first "German" king chosen from the house of Hannover to ascend to the English throne, in order to retain a Protestant monarchy. At the time of the American Revolution, King George III, his great-grandson, was the reigning British monarch and the first one of the family to be born on English soil. His grandfather George II's son Frederick Louis, the heir apparent, became a problem child to the royal world. Frederick, although married to a German princess (Augusta of Saxe Gotha), took a male lover (Lord Hervey), whom he shared with his mistress (Anne Vane). The prince was a patron of the arts, a playwright and a cricket master. In a resulting conflict with his father, he smuggled his wife out of court for the birth of her first two children. The first was a puny girl, the second a puny son who became King George III. The familial relationships aided in the military support given or sold to the British government.

THE LANDGRAVE OF HESSE-CASSEL: FREDERICK II (LANDGRAF FRIEDRICH II VON HESSEN-CASSEL)

The German princes had strong familial connections to each other and to the British monarchy. Frederick II, the landgrave of Hesse-Cassel, was married to Princess Mary of Britain and was George III's brother-in-law. Frederick converted to Catholicism, and therefore, Mary, a Protestant, left him with her son William. The landgrave took a mistress who had been attached to the Duc de Bouillon and over time and with other mistresses is reputed to have

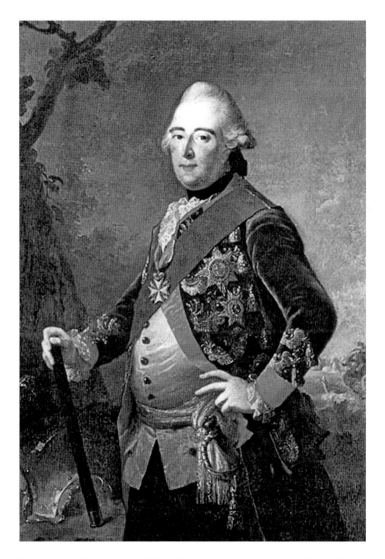

Frederick II, Landgrave of Hesse Kassel. Painting by Johann Heinrich Tischbein the Elder. *Museo Nacional de La Habana, public domain.*

produced over one hundred illegitimate children.[28] His lifestyle was based on the model of the French court, which included the grandiose expenditure for the accumulation of furnishings, clothing and other extravagances. The court language was French, used for communication with other princes, diplomats and military commanders. By 1781, his Hessian military force numbered approximately twenty-two thousand men of the small population of three hundred thousand. Frederick's extravagance was in direct contrast to

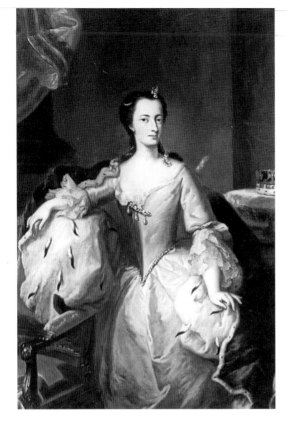

Left: Princess Mary of Britain, Landgravine of Hesse, by George Desmarée. *Museum of Hesse.*

Below: Marburg Castle in Hesse-Kassel. *Photo courtesy of the author.*

Hesse-Kassel from the castle. *Photo courtesy of the author.*

the poverty of his subjects. Although he did found schools and museums and left a full treasury at his death, money was needed to support his efforts. The monetary return for the twelve thousand men he sent to America diminished his subjects' taxes. He was one of the lesser evils of all the princes. Horace Walpole called him a "brutal German obstinate of no genius."[29]

THE ELECTOR OF HESSE-HANAU:
WILLIAM I (WILHELM I, KURFÜRST VON HESSEN)

Princess Mary had been married to Frederick II of Hesse-Cassel for fourteen years before her separation. In 1754, she came to Hanau with her three sons, including William, the eldest and the count of the territory. William was heartless and very fond of money and pleasure. His family had been renting soldiers for three generations.[30] When the news of Bunker Hill reached him in August 1775, he immediately offered a regiment of troops to his first cousin George III. He also negotiated for more funds, discovering that soldiers were being rented at a higher price per man from the other landgraves than those of his father. William had no qualms or timidity when

Courtyard of Marburg Castle in Hesse-Kassel. *Photo courtesy of the author.*

Above: Great Hall in Marburg
Castle. *Photo courtesy of the author.*

Right: William I, Elector of Hesse.
Unknown location, public domain.

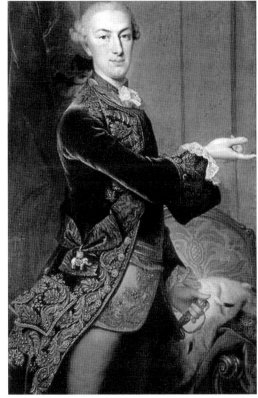

it came to taxes or revenues for "royal" use, and when his wife gave birth to their first child, he added a Kreutzer (one-cent) tax to the price of every bag of salt brought from the salt mines and used it for the care of the newborn baby. He needed the income from the soldiers to finance his seventy-four illegitimate children and to support his lifestyle. He received £12,000 a year as payment for his troops, while exempting the families of soldiers from his county's taxes.[31]

The Dukes of Brunswick-Wolfenbüttel: Charles I (Karl I von Braunschweig-Wolfenbüttel) and Karl Wilhelm (Ferdinand, Fürst und Herzog von Braunschweig Wolfenbüttel)

Karl I (Charles I) was a heavy-spending ruler of Brunswick-Wolfenbüttel, a land of 150,000 people, who put his small country deep in debt. The Seven Years' War was expensive, and his attempts at hiring alchemists to increase the treasury produced no gold at all. Many of his projects were positive and well-meaning, including financing an Italian theater director at a salary of 30,000 thalers; the founding of Collegium Carolinium as a school of higher learning in Wolfenbüttel; the founding of Fürstenburg Porcelain Company; and hiring the dramatist Gotthold Ephraim Lessing as his librarian. His uncontrolled spending left the finances of his country in shambles. In 1773, his eldest son, Charles William Ferdinand, Duke of Brunswick, a better economist than his father, took over the throne and

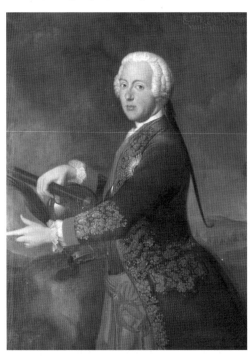

Charles I Duke of Brunswick Wolfenbüttel (Karl I). *Schloss Molsdorf Rudolstadt, public domain.*

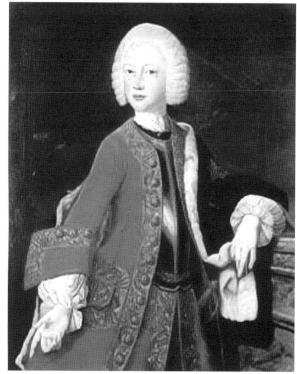

Above: Collegium Carolinium in Wolfenbüttel, now Natural History Museum. *Photo courtesy of the author.*

Right: Charles Alexander Margrave of Brandenburg Anspach, painted by unknown artist. *Unknown location, public domain.*

started a lottery to raise funds for his country. He was George III's brother-in-law by way of his marriage to his sister Augusta. He supplied 4,300 men to the British army and received £160,000 by the end of the war, representing less per head than the other states.

Prince Friedrich Karl August of Waldeck-Pyrmont

Waldeck was a small country ruled by Prince Friederich Karl August, who sent 1,225 soldiers to America, of whom 720 never returned. Many Waldeckers were slated for duty in Holland even as the prince was sending troops to the New World.

The Margrave of Brandenburg-Ansbach-Bayreuth: Charles Alexander (Christian Friederich Karl Alexander)

Prince Charles Alexander, the margrave of both Ansbach and Bayreuth, was the son of "der Wilde Markgraf" and, through his mother, Princess Frederike Luise of Prussia, the great-grandson of George I. His father committed capricious murder of random subjects, many for apparently for no reason, but Charles was fond of building castles and villas for his mistresses. To support the construction of three of them, he used the rental of his county's troops, sent both to Holland and England as an auxiliary source of income. A total of 2,353 men were shipped to the "colonies"; the duke was paid £100,000 for them. Despite his efforts, he eventually was forced to sell both countries to Prussia.

Relief on Marburg Castle, military in 1142. *Photo courtesy of the author.*

PRINCE FRIEDRICH AUGUSTUS OF ANHALT ZERBST

Friedrich, the younger brother of Catherine the Great of Russia, ruled a country of twenty thousand subjects. His army was recorded as numbering two thousand but in reality was smaller than that. When he agreed to send them to the colonies, the number of available soldiers was so low that he had to go out of his own dominion to find soldiers and officers. He sent six hundred men to the colonies. He was not concerned with his subjects or their affairs, ordering his servants not to trouble him with commonplace issues, on the pain of dismissal.

Prince Friedrich Augustus of Anhalt Zerbst. *Unknown artist and location, public domain.*

Signing Up the Princes

The princes sent soldiers under signed "contracts," or treaties, which had been negotiated with the representative of the British government. The issue was the negotiated amount of money per soldier. The American colonists, alarmed about a foreign military presence, were aware that the British were commissioning a large auxiliary army. The total number of men commissioned by the British government from the German princes was approximately 28,883, of whom 18,560 did not return. If the Gibraltar forces are counted, the German states supplied 30,783 soldiers to the colonial conflict.

In the fall of 1775 the British government enlisted Colonel William Faucitt (Fawcett) of the British Foot Guards, stationed in Germany. He was initially sent to negotiate a contract with Lieutenant Colonel George Heinrich Albrecht von Scheither, an independent military "enterpriser" who, in the fashion of the Thirty Years' War, would personally recruit and pay soldiers and place them under his command, finally selling them as whole units. In modern terms, he was a vendor of military mercenaries. Scheither contracted to supply 2,000 recruits for British regiments; if he succeeded, he would be commissioned to gather another 2,000 men. He got paid ten pounds per man, from which he was to keep all but the cost of food, bounty and fees to subordinate recruiters. Faucitt would have the last word on the individuals' fitness for service.[32] Colonel Scheither recruited the contracted 2,000 men, of whom 113 deserted and another 161 were rejected. The colonel's profit margin was not as he expected, so he declined recruiting 2,000 more men. In total, 400 of his recruits did land in the Twenty-second Regiment of the British army. Many more recruited Germans were part of the following regiments that served in New Jersey: Fourth, Fifth, Tenth, Seventeenth, Twenty-second, Twenty-third, Twenty-eighth, Thirty-fifth, Thirty-eighth, Fortieth, Forty-sixth and Fifty-fifth.[33] A letter from Lord Barrington to General Howe, written on May 28, 1776, delineates their rank and pay:

> *A body of German recruits being directed to embark for North America, to be incorporated into the regiments, he sends copy of distribution for same. Sergeants and corporals are to continue to do duty and receive pay and clothing as sergeants and corporals according to the rank in which they have been sent over. And the difference of pay and clothing between commissioned officers and privates is to be made a charge in the contingent bill of the regiment to which they belong.*[34]

Right: Hesse-Kassel, 2015. *Photo courtesy of the author.*

Below: The harbor at Bremen Veggesack, 2015. *Photo courtesy of the author.*

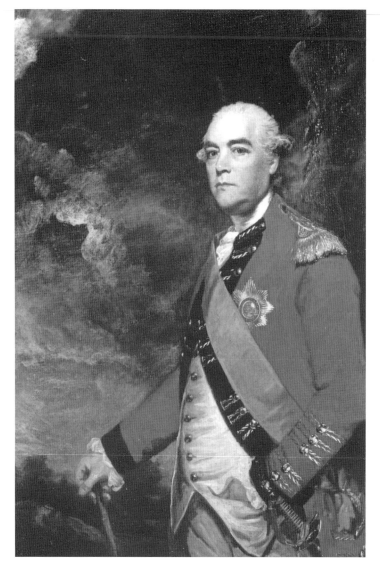

Sir William Faucitt, by Sir Joshua Reynolds. *National Portrait Gallery, London.*

The search for military support continued at the same time during that fall, when the British cabinet tried to get between twenty thousand and twenty-five thousand soldiers from Russia. When Catherine the Great refused, William, the prince of Hesse-Hanau, offered five hundred men to his cousin, King George III. William wrote:

I dare to offer my regiment infantry composed of five hundred men all sons of the land which the protection of your Majesty alone insures to me, and all ready to sacrifice with me their life and blood for your service.[35]

The Prince of Waldeck, Friederich Karl August, wrote in November 1775 offering six hundred men, while the other princes waited to be approached by Ambassador Colonel William Faucitt (aka Faucet, or Fawcett), who would foster an agreement with each prince or duke. The treaties for auxiliary troops had to be signed and sealed before the approval of Parliament for the enactment of the terms (see appendix B). This agreement allowed the pursuit for manpower from the other dukes by Colonel Faucitt, who was the deputy adjutant general to the German army. A hero during the Seven Years' War, he was fluent in German and French and was successful in procuring the Anglo-German treaties. Faucitt was promoted to major general, although each one of the "contracts" with each leader and kingdom was different. The recruitment of troops passed from private recruiters to the princes, who did not have to "round up" an army but had them on hand.

Soldiers were offered by the elector of Bavaria and the duke of Württemberg but were rejected by the crown's emissary because of their poor quality and bad equipment, in addition to the refusal of Frederick the Great to allow regiments to pass through his kingdom. The first treaty, of January 9, 1776, was made with the duke of Braunschweig, promising the delivery of completely equipped infantry (3,964) and unmounted dragoons (336). They were scheduled to leave in February and March 1776, with care being taken by the king to prevent desertion on their way to the sea.

German dukes would often pocket the difference between the money received for the units and the actual pay made to the soldiers. Therefore, the British government sent the pay directly to the men who arrived in America. The only country to avoid "direct deposit" was Hesse-Cassel. Provisions were made in the treaty for the medical treatment and transportation of the wounded at the king of England's expense. The duke would supply equipment and clothing and would also benefit from a built-in insurance policy. If shipwreck or epidemic would strike a German troop, the English king would have to bear the cost of replacement.

The duke retained the right to nominate officers and administer military justice and was given the guarantee that the German soldiers' duties or service would not be unusual or other than that of the British regular army. The amount to be paid to the duke for each soldier was to be borne by King George, including 30 crowns per head, which was equal to £7, 4s. 4d. ($868 in today's

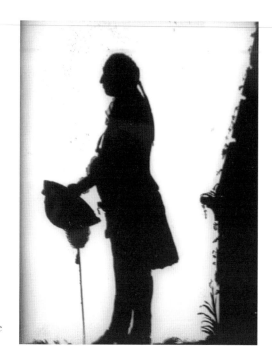

The shadow of the Landgrave. Frederick III. *Scherrenscnitte* (Silhouette Art). *Marburg Museum.*

money), in addition to which he had to pay £11,517, 17s. 1d. (about $1,390,000) annually from the day of the signature on the treaty while he was paying the troops and double that amount for two years after the soldiers returned from the colonies (£23,035, 14s. 3d.) ($2,738,000). In addition to the expensive military investment, he also had to pay each soldier two months' pay in advance.[36]

The section of this treaty that smacks of human trafficking reads as follows:

> *According to custom three wounded men shall be reckoned as one killed; a man killed shall be paid for at the rate of levy money, which connects to a previous clause directing the English Crown to pay for a new recruit to replace a fallen soldier, and a condition as well which has the Duke paying for the replacement of a deserter.*[37]

This agreement, which does not appear in the Hesse-Cassel treaty, caused many a German deserter in America to change his name. The duke received about $35.00 ($915.00) in American money of the time for a dead soldier and $11.66 ($315.00) for a wounded one. No record had ever been kept of the total monies that changed hands with this agreement.

The Hesse-Cassel tariff, paid to Frederick II, was different than that of Braunschweig. Although the monetary amount was the same per man, the

general subsidy was larger at £108,281, 5s. ($13,000,000) per year and continued for one year after the troops returned home. His army, however, was to remain in units with German commanders and medical personnel. Twelve thousand men were supplied while the duke continued to make "side deals" for more troops supplied piecemeal throughout the conflict. In all, he received twice as much per man than did the duke of Brunswick, and he demanded and got a payment of an old claim from the Seven Years' War of £41,820, 14s. 5d. All in all, the Revolution in the colonies was costly to the British.[38] The other princes and dukes of Hesse-Hanau, Waldeck, Ansbach Bayreuth and Anhalt-Zerbst signed similar but less lucrative agreements. Bargains for small additional bodies of troops, including chasseurs and sharpshooters, were made for the duration of the war. These rulers took over the marketing of soldiers from the independent recruiters of earlier wars and became the main source for auxiliary armies. The British government had to create an income stream for financing these purchased armies and created one of the very first "national debts."

Voices across Europe were raised in protest as the contracts were being signed. Honoré Gabriel Riqueti, comte de Mirabeau, a noble who became a voice of the French Revolution, was exiled in 1777 in Holland, where he wrote a twelve-page pamphlet, *Advice to the Hessians*, printed in Cleves. It was a response to Frederick II of Hesse-Cassel's sale of troops to the British.[39] He wrote with romantic fervor:

> *Brave Germans! What disgrace are you allowing to be branded on your generous brows! At the end of the eighteenth century shall the nations of the centre of Europe become the mercenary satellites of odious despotism? Shall those valiant Germans who so vehemently defended their freedom against the conquerors of the world, and braved the Roman armies be basely sold, and shed their blood to support the cause of tyrants? Ye are sold!—and wherefore, Great God!—To attack a people defending the most just of causes, and who are setting you the noblest example. Why do you not imitate the brave people instead of attempting to destroy them?*[40]

The epitaph of the booklet is a quote from Virgil: "What madness is this? Oh, where are you going now where? Poor citizens! Not the enemy but your own hopes."[41] Mirabeau's pamphlet was translated into five languages and was one of the major outcries against the "rented" troops. Frederick II, or Frederick the Great of Prussia, was a strong opponent of the process, and on June 18, 1776, he wrote to his close friend Voltaire:

Had the Landgrave come out of my school, he would not have sold his subjects to the English as one sells cattle to be dragged to the shambles. This is an unbecoming trait in the character of a prince who sets himself up as a teacher of rulers. Such conduct is caused by nothing but dirty selfishness. I pity the poor Hessians who end their lives unhappy and uselessly in America.[42]

The beloved south German and national poet Friedrich Schiller wrote a play during the American Revolution titled *Cabale und Liebe* (Cabal and Love) about the destruction of love in the higher echelons of a noble's court. It included a protest against German troops being sent to America. Lady Milford, who had heard nothing of their duke's arrangement with the English Crown and of her old chamberlain's two sons being sent, asks:

LADY MILFORD: But none of them were forced to go?
CHAMBERLAIN: Oh God no, all volunteers. It is true a few saucy fellows stepped out of the ranks and asked the colonels how much a yoke the prince sold men; but our most gracious master ordered all the regiments to march on to the parade ground, and had the jackanapes shot down. We heard the crack of the rifles, saw their brains spatter the pavement, and the whole army shouted, "Hurrah! To America!"
LADY: Oh God! Oh God! And I hear nothing and I noticed nothing.
CHAMBERLAIN: Yes, madam! Why did you ride out to the bear-hunt with our master, just as the signal was given to march away? You should not have missed that imposing spectacle, when the loud drums told us the time was come and shrieking orphans here followed a living father, and there a raving mother ran to impale her sucking babe on the bayonets. You should have seen how lovers were torn asunder with sabre strokes, and old graybeards stood still in their despair, and at last threw their very crutches after the young fellows who were starting for the New World. Oh! and through it all, the noisy rolling of the drums, so that the Almighty might not hear us pray!
LADY: Be quiet, poor old man! They will come back. They will see their home again.
CHAMBERLAIN: Heaven knows it! So they will! Even at the city gates they turned and cried, "God help you, wife and children! Long live our father the duke! We shall be back for the Day of Judgment!"[43]

The artistic voices of protest didn't seem to impact the states of Germany. The soldiers were not totally signed, sealed and delivered, for they had to be approved by the British Parliament.

4.

THE KING, THE TREATIES, THE PARTIES AND PARLIAMENT

King George III was adamant about suppressing the rebellion in "divers parts of our Colonies and Plantations in North America." Despite objections against military action from members of Parliament, the king issued a "Proclamation, Suppressing Rebellion and Sedition" on August 23, 1775. He stated:

> Hereas many of our subjects in divers parts of our Colonies and Plantations in North America, misled by dangerous and ill designing men, and forgetting the allegiance which they owe to the power that has protected and supported them; after various disorderly acts committed in disturbance of the publick peace, to the obstruction of lawful commerce, and to the oppression of our loyal subjects carrying on the same; have at length proceeded to open and avowed rebellion, by arraying themselves in a hostile manner, to withstand the execution of the law, and traitorously preparing, ordering and levying war against us: And whereas, there is reason to apprehend that such rebellion hath been much promoted and encouraged by the traitorous correspondence, counsels and comfort of divers wicked and desperate persons within this Realm.[44]

His stance set the stage for the acquisition of more military to be sent to the colonies; over the objections of Parliament members, he ordered his ambassador, Faucitt, to find soldiers from the princes and dukes of Germany. The proposal reached a vote of approval in 1776 by the Tory majority in

the House of Commons, but the Whig opposition fostered objections over the whole idea of suppressing a rebellion of "our own citizens." Lord North (Frederick North, Second Earl of Guilford), the prime minister, made a motion to send the treaties to the Committee of Supply, indicating that the acquisition of the German troops was the best and quickest method of bringing America to a state of obedience to the Crown.[45] He claimed it was cheaper and quicker than raising the troops at home. North was supported by Charles Wolfram Cornwall, who thought the terms of the treaty were a great advantage and it was cheaper than any alternative. Lord George Germaine argued that England had always used foreign soldiers in the past; Lord John Cavendish opposed the agreements on the grounds that, according to the treaty, the foreign soldiers would be under the command of their own officers and not the king's or Parliament's. Lord Irnham (Simon Luttrell) was opposed to the acquisition of foreign troops because it would disgrace England in the eyes of all of Europe. Conway Seymour noted that the expense of the rental was too high, while James Luttrell voiced further objection on the grounds that the 150,000 Germans already settled in America would cause the troops to desert. Edmund Burke, Sir George Saville and Alderman Bull joined the opposition to the measure in the debate, but the end was determined probably by the will of the king. The motion to "rent soldiers" was passed, 242 for and 88 against.

When the motion was passed to the House of Lords, the duke of Richmond, Charles Lennox, presented a motion that a "humble address" be presented to George III to countermand the hiring of the foreign troops and to suspend hostilities in America.[46] He indicated that this acquisition would indicate a weakness on making his country vulnerable for foreign attack and that reconciliation with the colonies would be better for everyone in the long run. The duke introduced the history of dealing with the landgraves since 1702 and indicated the inconsistency and extortion on the part of rulers agreeing to this treaty:

> *A downright, mercenary bargain, for the taking into pay of a certain number of hirelings, who were bought and sold like so many beasts for slaughter. . . . But taking it on the other ground, that the treaties were formed on the basis of an alliance, what would be the consequence? That if any of these powers were attacked, or should wantonly provoke an attack, for the engagement was left general and unconditional, we should give them all the succor in our power. Thus, for the assistance of a few thousand foreign mercenaries, we are not only to pay double, but we are to enter into a solemn*

engagement to exert our whole force to give them all the succor in our power,
if the Landgrave or the Duke shall be attacked or disturbed in the possession
of his dominions.[47]

The debate raged on, but as it did in the House of Commons, the same result ensued. German troops were hired as planned, as the monarch wanted; however, there was a backlash from the very colonies that were rebelling. The news of the treaties reached America and caused the following passage by Thomas Jefferson to be included in the Declaration of Independence, which referred to King George III:

He is at this time transporting large armies of foreign mercenaries to compleat
the works of death, desolation and tyranny, already begun with circumstances
of cruelty and perfidy unworthy the head of a civilized nation.[48]

The rebel colonies believed that they could engage France for help if the British used Hesse as a paid ally. The troops "rented" from the German states were now a factor and were ready to be shipped to America. There is very little written in popular American history about the conflict in the British houses and the role of King George III in the selection of "borrowed" military. The actual mercenaries in the process were the landgraves, who profited greatly—not the hired soldiers who had to go into battle.

5.

German Soldiers and Their Journeys

Getting to the Colonies

After signing the contracts with the English Crown, the landgraves had to obtain the correct number of troops to supply to Britain. Hesse-Cassel was divided into districts, and each was directed to furnish a given number of recruits to a certain regiment.[49] The officers were directed to enlist as many "foreigners" as possible, for two apparent reasons: they could be recruited in time of need; and they would remain to pay taxes to the regent. A "foreigner" in eighteenth-century Germany was someone who lived outside the landgraves' district, including farmers and laborers from another district. For example, in Company von Dechow in the Hessen Cassel unit, Antonius Steinhausen was born in Günzburg an der Donau, in the small principality of Burgau.[50] Most of the other soldiers in this particular unit came from the rural areas around Ziegenhain and Schönstein in Hesse-Cassel.[51] Ansbach had tighter control over its citizens—no one could leave the country or marry without governmental permission. This law meant that leaving for anywhere outside Ansbach was forbidden unless ordered by the duke.[52]

The landgrave's territories may have been sacrosanct, but the recruitment of "foreign" soldiers was not. Johann Gottfried Seume, a writer of some prominence after the war, kept a sort of diary, later published in 1813, titled *In Hessian Lands.*[53] In it, he tells of being abducted into the Hessian army headed for America in Ziegenhain while he was on his way home from the university. There are few diaries of this type, because the rank and file of the German troops was largely uneducated and illiterate. Seume describes his fellow abducted colleagues:

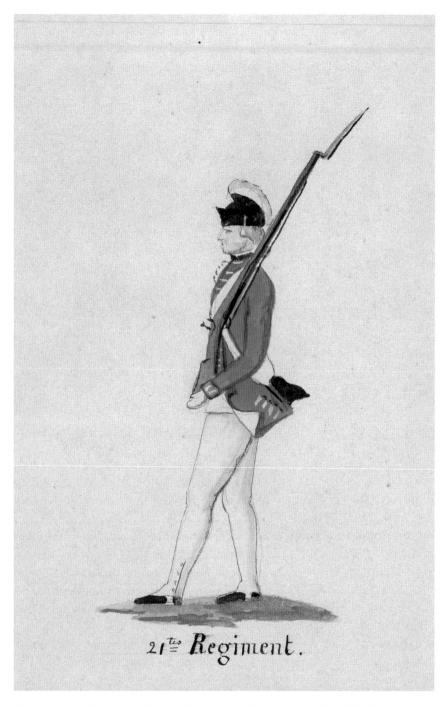

Drawing of a soldier from the Twenty-first Regiment Braunschweig. *Stadt Archiv Braunschweig.*

My comrades were a wayward student from Jena, a bankrupt merchant from Vienna, a lace maker from Hannover, a dismissed postal clerk, a monk from Würzburg, an upper bailiff from Meinungen, a Prussian hussar sergeant, a cashiered Hessian major from the fortress, and others of similar ilk.[54]

His account of the journey to America includes crowded conditions during the transport, abuse and severe restrictions on behavior. According to Seume, each unwilling recruit was stripped of his clothing each night so that he couldn't escape, and each was carefully monitored so that he wouldn't desert. There was, Seume writes, a mutinous plot of mass escape; however, the ringleaders were caught, two condemned to be hanged and the remainder had to run the gauntlet (a favored method of punishment).[55] The two plotters were eventually pardoned to be jailed. However, they were worth more to the prince as cannon fodder, so they were released to rejoin the troops.

The journey to America was certainly not an easy one. The first part of the trip, through the territories of the various landgraves, was difficult because of possible desertions among the newly recruited units. The same issue did not hold true for the more hardened troops from Braunschweig, veterans of the Seven Years' War. They were the first to start for the colonies; on February 22, 1776, 2,282 left from Stade at the mouth of the Elbe River, with 2,000 more men leaving at the end of May.[56] The first Hessian units left Cassel in early March and journeyed to Bremerlehe, near the mouth of the Weser River, considered the main port of debarkation. However, the different units left from different ports in Germany to Portsmouth in England. The Waldeck Regiment, for example, left from Vegesack (Bremen-Vegesack today),[57] which is no longer in use since it partially dried out and became unusable for large ships. The German port cities were too small to accommodate a great number of troops, so the men were sent at different times to separate places. The second wave of Hessians left in June, while the recruits (44) bound for service in the actual British army left in May 1776 from Portsmouth in England.[58] The total number of "Hessians" was between 12,000 and 13,000 men. The overland march from either Cassel or Braunschweig was not a problem, since the regiments passed through the kingdoms of their own princes and then through the territory of the Hannoverian areas ruled by George III of England. The other regiments from Hesse-Hanau, Ansbach Bayreuth and Anhalt Zerbst had a difficult time. Frederick the Great wrote to his nephew, the margrave of Ansbach Bayreuth, forbidding him to use the

The harbor at Bremen Vegesack, 2015. *Photo courtesy of the author.*

Prussian lands as a route to England and on to America. On October 24, 1777, he wrote to his nephew:

> *Monsieur My Nephew—I own to your most serene highness that I never think of the present war in America without being struck with the eagerness of some German princes to sacrifice their troops in a quarrel which does not concern them. My astonishment increases when I remember in ancient history the wise and general aversion of our ancestors to wasting German blood for the defence of foreign rights.*
>
> *But I perceive that my patriotism is running away with me; and I return to your Most Serene Highness's letter of the 14ᵗʰ, which excited it so strongly. You ask for free passage for the recruits and baggage which you wish to send to the corps of your troops in the service of Great Britain, and I take the liberty of observing that if you wish them to go to England, they will not even have to pass through my states, and that you can send them a shorter way to be embarked. I submit this idea to the judgment of your Most Serene Highness, and am none the less, with all the tenderness I owe you. Monsieur my Nephew, your Most Serene Highness's good uncle,*
>
> *Frederic.*[59]

Frederick would not bend on his stance, and even after some negotiation, the troops remained stalled on the Rhine near Bendorf (owned by the margrave of Anspach). The difficulty in moving the regiments up the Rhine was a result of the concern with the possible interference by local princes and also with the numerous tollbooths along the way. The first regiment from Hanau passed through the Rhine unmolested; however, the passage of these troops caused trouble for their followers. On March 7, 1777, Hanau chasseurs and recruits were stopped at Mainz, where eight men were removed when the archbishop claimed them as deserters from his own troops. When the regiment got to Holland, seven men jumped overboard, with three of them escaping permanently.[60] In Ochsenfurt on March 10, 1777, a mutiny and riot was caused by crowded conditions on the boat now waiting on the Rhine. Men climbed to land over planks laid from boat to shore, and finally, after food and drink, they began to fight the chasseurs who were sent to oversee them. The margrave of Anspach galloped to the site and reviewed the men, asking their grievances and offering to set them right. He also promised that any man may leave the service if he gave up his home, lands and "Princely favor."[61] There are only two accounts of this incident, and the repeated history of this event is based on them. There appears to be no primary sources. Frederick the Great's mandate only caused the journey to be a longer one, and Ansbach regiments that left in early November 1777 did not land in New York until September 1778.

According to the Seume diary, the ships were crowded, dangerous and just bearable. Did Seume exaggerate? Later authorities questioned the diary's veracity. Not all of the men, however, went unwillingly into the princes' service. Some went for adventure; many were drafted; others chose a way to continue to make a living; and still others went to see if they could gain property in the New World. But the fear of desertion was a prevalent—and real—one among the officers' class. The soldiers were not hardened, traditional mercenaries who were paid to fight.

The journey was one problem, but the preparation of these soldiers was another. They left rural Germany, for the most part, and marched and sailed off into unknown territories. Some had relatives in the colonies, and although letters from the New World were rare, there was an awareness of where the family landed. The men from Bendorf, for example, had relatives in New Germantown and German Valley, New Jersey.

In addition to a miserable journey, the majority of men did not know what to expect on their arrival. They avidly listened to secondhand accounts of rebels who would murder on sight and either eat or scalp the enemy.

Some were told to bayonet the enemy through the chest as a preventive measure. They must have had a preconceived notion of a wild country; however, upon arrival on Staten Island, the soldiers found housing and living far superior to that of the German farmer. No time was lost putting these men into action; they were shipped to Long Island, where they successfully defeated the Continental army, eventually driving it across the Hudson River into New Jersey.

These were scared men in an unknown country with an unknown language and strange surroundings. Their first taste of combat was the battle on Long Island, one that is not a highlight of American heroics because of the devastating losses by the colonial forces. George Washington fled to the upper regions of Manhattan Island, Washington Heights and, after some maneuvering, enabled his army to escape and eventually occupy Fort Washington and the surrounding area. The Hessians were camped as far north as today's 204th and 205th Streets and Broadway in Manhattan. On November 20, 1776, the British and Hessian troops crossed the Hudson into New Jersey.

6.

THE LEGENDARY BATTLE OF TRENTON

Drunk or Not?

As the American officers had anticipated the Hessian troops at Trenton, carelessly confident in their own military strength, entered eagerly into the Christmas revelry as they did at home, and all day and far into the night they continued their merrymaking, with some feasting and much drinking with the people of the town.
—The Battles of Trenton and Princeton[62]

Meanwhile, Washington had not been mistaken in supposing that the Hessians, unsuspicious of peril, would be spending the hours in carousal. Many of the British light-horse were off on foraging or pillaging expeditions, and the Germans were making night hideous with their songs and shouts and drinking bouts. Colonel himself, the commander of the Hessians, was spending the night in the home of Abraham Hunt, a man who had dealings with both sides and was true to neither. On this particular night, Hunt had invited Colonel Rall and a few others to a "Christmas supper" at his house, and far into the night the unsuspecting officers continued their card-playing and drinking. Colonel Rall was about to "deal," when his negro servant, against express orders, entered the room, and thrust a note into the Hessian's hand, explaining that the man who had brought it had first begged to be permitted to enter himself, but had been refused, and that then he had written the note and declared that Colonel Rall must have it immediately, as it was of the very highest importance. If the colonel had known that the note was a word brought by a Tory who had discovered the presence of the advancing American army, it is more than likely that the history of the Revolution would have been far different from what it was. However, Colonel

Rall did not stop his game, but thrust the note unread into his pocket, and so never knew of Washington's approach until it was too late to act.
—*Everett Tomlinson,* A Short History of the American Revolution[63]

Washington's army, in Philadelphia in late November 1776, was in dire straits. The terms of enlistment were up on November 30; a detachment under General Lee was left on the east bank of the Hudson, and twenty-four hundred men under Lord Stirling were protecting northern New Jersey, eventually moving to defend the upper Delaware River line. Lee refused orders to join Washington, which left the general with fewer than thirty-five hundred men. The British were on the march across New Jersey, so Washington retreated as they came, burning bridges as he went. On December 8, he crossed the Delaware, taking all the boats for seventy miles to his own side. There was panic in Philadelphia as Congress moved to Baltimore for safety.

Another enemy general might have chased these ragged, tired troops; however, British general Howe was not one to pursue in the winter weather. He returned to New York, a Loyalist haven at that time, leaving Colonel Karl von Donop, Major General James Grant and General Charles Cornwallis in command in New Jersey. Von Donop was the acting brigadier with two Hessian brigades, the Jaegers and the 432nd Highlander. The idea was that he would hold the line from Trenton to Burlington. Cornwallis, in turn, left Grant in command and went home to England. The orders left to von Donop were "supposedly" to hang any rebels who fired at the army.

It is at this point that accurate history can become legend and myth. There are reports, as told by historian George Bancroft, of plunder and outrages and acts of rape on the part of the Hessian soldiers. After the war, people in the area sued the government for reparations. There is little written on the part of the colonists or the Hessians, since both were either illiterate or ignorant of the other's language. Bancroft, with no real substantiation, writes of the Hessians:

> *Life and property were at the mercy of foreign hirelings. There were examples where English soldiers forced women to suffer what was worse than death, and on one occasion pursued girls still children in years who had fled into the woods. The attempts to restrain the Hessians were given up, under the apology that the habit of plunder prevented desertions. A British officer reports officially, "They were led to believe, before they left Hesse Cassel, that they were to come to America to establish their private fortunes, and hitherto they have certainly acted with that principle."*[64]

Right: Memorial to the victors, Battles of Trenton and Princeton, Nassau Street, Princeton. *Photo courtesy of the author.*

Below: Battle of Trenton Memorial. *Photo courtesy of the author.*

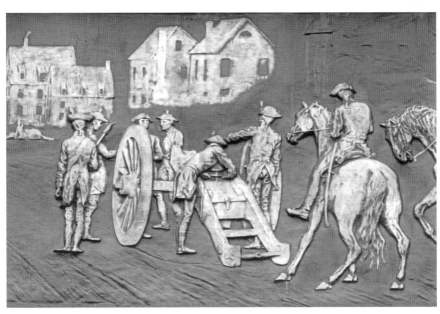

The Bancroft account is based on postwar claims for reparations by the newly minted Americans. Some of these are exaggerated, and others could be true. Bancroft turned isolated incidents into broad generalities. Washington wrote on February 5, 1777, about the Hessians:

> *One thing I must remark in favor of the Hessians, and that is, that our people who have been prisoners generally agree that they received much kinder treatment from them than from the British officers and soldiers.*[65]

Colonel von Donop thought that Trenton should be protected by redoubts on its flanks; Hessian maps of 1777 show all of the existing colonial redoubts in northwest New Jersey, along with the names of colonists who owned farms in the area. The redoubt fort was considered essential for this kind of warfare; however, Von Donop lost this argument to Colonel Rall, who, as a reward for his brilliance at Fort Washington in earlier service, obtained command of the Trenton post with fifty jaegers, twenty dragoons and his own brigade composed of three regiments of Hessians called Rall, Von Knyphausen and Von Lossberg. He ignored Von Donop's suggestion. The Von Donop brigade, with the Forty-second Highlanders, marched into Bordentown, where the general found lodging in a private house.

The stage was set for Washington's Delaware crossing. The German soldiers were spread across Trenton, which today is an area that can be covered by a short walk. The Rall and Von Lossberg Regiments were quartered in the northern part of Trenton, and the Von Knyphausen Regiment was in the southern part, on both sides of the Assunpink Bridge, on which there were twelve men.[66] The rest of the soldiers were scattered around the town in different houses; fifteen were billeted in the "Old Barracks."

Colonel Johann Gottlieb Rall (Rahl), a veteran soldier, bore most of the blame for the British loss at Trenton. At the time of this encounter, he was fifty years old and had served in the military for thirty-five years, starting in his father's regiment as a cadet in 1741. By 1763, he had been promoted to the rank of lieutenant colonel. The noteworthy difference in the rise in ranks in the German and British armies was the contrasting method of promotion. British army officers purchased their ranks, while the German soldier was promoted by merit. Rall fought in the War of Austrian Succession, in the Netherlands and in the Seven Years' War. He had served in Scotland for the Jacobite "risings" with the duke of Cumberland and finally for Catherine the Great in the fourth Russo-Turkish War.[67] His service record raises some interesting issues.

Did Rall speak any English, or did he converse with the British officers in French? Did Rall view the rebels in the colonies with the same disdain that was evident during the Battle of Culloden in Scotland, a bloody slaughter lasting only forty-five minutes? He was well liked and respected by the men whom he commanded. Lieutenant Jakob Piel wrote in his diary:

> *Considered as a private individual, he merited the highest respect. He was generous, magnanimous, hospitable, and polite to everyone; never groveling before his superiors, but indulgent with his subordinates. To his servants he was more a friend than master. He was an exceptional friend of music and a pleasant companion.*[68]

The other officers, his colleagues, did not share these feelings but viewed him with contempt because he kept referring to his combat experience. Rall thought there was no need for the construction of forts (redoubts), while Colonel von Donop thought they were needed to defend against enemy attack. Rall used his battle experience as a lever to denigrate the idea of building them. Contrary to popular historical accounts, the entire American army was not huddled in the snow across the Delaware. Major General Philemon Dickinson left his house in Trenton and moved upriver to Hunterdon County, where he organized the local militia to harass the Hessian troops as much as possible. Rall, commanding exhausted men, requested help from the British forces, which was not forthcoming. Meanwhile, Brigadier General James Ewing had five regiments detailed to keep the Hessians on the New Jersey shore; to achieve this, he controlled all the boats on the river near and around Trenton. Sporadically, and without warning, Ewing's six hundred men and some thirty artillery shelled the Hessians. On December 17, thirty men were sent across the Delaware to attack a Hessian outpost, and at sunrise of the next day, Ewing sent a larger party to attack the spot again, inflicting more damage. The attack was continued on the twenty-first with a raid on Trenton Ferry Landing, driving the Hessians back into Trenton. The Americans burned the houses of the landing, which prevented Rall's men from using them as shelter in the winter weather.

Rall countered by keeping every man in his units "under arms"; each morning, he would lead two columns up and down the river, looking for the colonials. Colonel von Donop and his other officers still suggested that they construct redoubts on the heights above Trenton, to which Rall replied, "I have not made any redoubts or any kind of fortifications because I have the enemy in all directions."[69]

The response to Rall's request for reinforcement was forwarded to General James Grant, who had utter contempt for the American troops. It is his answer that probably helped cause the defeat in Trenton:

Tell the Colonel [Rall] that he is safe. I will undertake to keep peace in Jersey with a corporal's guard.

In response to another plea from Colonel Rall, Grant wrote:

I am sorry to hear your brigade has been fatigued or alarmed. You may be assured that the rebel army in Pennsylvania which has been joined by Lee's Corps, Gale's and Arnold's, does not exceed eight thousand men, who have neither shoes nor stockings, are in fact almost naked, starving for cold, without blankets, and very ill-supplied with provisions. On this side of the Delaware they have not three hundred men. These are scattered about in small parties under the command of subaltern officers, none of them above the rank of captain, and their principal object is to pick up some of our light dragoons.[70]

Meanwhile, General Count Carl Emil Ulrich von Donop, who hated Rall because of the difference in their social rank and military importance, felt that his position as the personal adjutant to the landgrave gave him priorities and privilege. He was at Bordentown; his plan to absorb Rall's regiment into his own was rejected by British general Grant. Therefore, von Donop's garrisons were spread along the countryside of New Jersey. On December 22, colonial troops under Colonel Samuel Griffin attacked the outposts at Slabtown (now Jacksonville); in response, von Donop moved his regiments south through a battle at Iron Works Hill, and by Christmas Eve, he was in Moorestown. Although his officers wanted the regiments moved to Bordentown to support Rall, Count von Donop, displaying his contempt for Rall, spent Christmas in the company of a beautiful young widow in Mount Holly, New Jersey. Some say she was the famous Betsy Ross; however, she was more likely Mary Magdelene Bancroft, a beautiful young woman staying with relatives in the area while her husband, Dr. David Bancroft, was in British prison accused of being an American spy. Mary's great-aunt, of the same name, had lost her husband in an American prison for being a Loyalist spy and was therefore sympathetic to von Donop and his companies. The relationships and convoluted travels of this family are lengthy and detailed; however, it is safe to say that this upper-class young lady was in

Mount Holly with Colonel von Donop and would have certainly caught his eye.[71] He had settled down in either a local tavern or, as many local legends say, at Ridgway's Lanthorn, an elegant mansion more fitting to the tastes of a courtly gentleman. Captain Johannes Ewald of the Jäger Division noted in his diary:

> *The colonel (von Donop), who was extremely devoted to the fair sex, had found in his quarters the exceedingly beautiful young widow of a doctor. He wanted to set up his rest quarters (winter quarters) in Mount Holly, which, to the misfortune of Colonel Rall, he was permitted to do.*[72]

This "dalliance" may have caused the loss of Trenton. By the time a haggard messenger arrived with the news of the defeat at Trenton, it was too late for von Donop to move his troops and give support. Could his return to Trenton have helped Colonel Rall's position and turned the tide of the battle? Why was Betsy Ross's name attached to von Donop's visit as part of the rumor of his stay in Mount Holly, or was the mysterious woman seen there a spy sent by Washington, who had used a fake exchange of prisoners' message to locate von Donop's troops? We probably will never know; however, the most likely candidate is Mary Magdelene Valleau Bancroft.

On Christmas Eve, Colonel Rall had settled in to play checkers, chess or cards, depending on the account, at the Hunt house or at the Potts' house. Washington, meanwhile, was preparing his troops to cross the Delaware as the German soldiers were supposedly celebrating and not paying attention to the battles. William Stryker wrote:

> *Christmas night was chosen for the attack by reason of the Hessians' well-known leaning toward unrestrained Yuletide celebrations. Hearty drinking and a momentary lapse of discipline were counted on, and not in vain, as the natural consequences of the Teutonic seasonal observance.*[73]

Stryker's idea of the "Teutonic seasonal observance" was incorrect. In Germany and in most German families, Christmas Eve is the Holy Night. Most of the Hessian soldiers were Evangelical Lutheran or German Reformed; some from Bavaria or south Germany were Roman Catholic. A drunken celebration would be foreign to all of them on this night. Furthermore, they were exhausted from "rebel" attacks earlier in the week and were spread through the small town of Trenton, had slept in their gear and had been awakened at odd hours over the three-day period to stand guard.

Von Donop was quick to write a letter to the landgrave on December 27, 1776, in which he refers to the Rall brigade involved in the "loathsome affair" and to absolve himself of any blame for the defeat:

> *I notified Col. Rall immediately of the fact with the advice to be on his guard because I believed that while the enemy would make an attack* [on] *me, they would also* [sic] *make an attack upon him.*[74] . . . *The death of Col. Rall has therefore turned off a painful investigation and great responsibility to which he would have been held to answer.*[75]

An investigation into the "affair" happened anyway. Rall was posthumously court-martialed on April 13, 1778, by the German armies in Philadelphia examining the whole "Trenton Incident." Testimony given by several officers and men supports the tale of the tired soldiers. Twenty-two-year-old Lieutenant Henry Reinhard Halle, from Rinteln, a small town on the Weser River, testified:

> *Pickets* [were] *put on the Delaware, to 1 officer and about 20 men to a picket. In the beginning there was an examination of guns in the evening, the guns had to be put together at the Captains quarter and every company had one or two Alarm Houses assigned to them, where they had to stay all night fully dressed up except the leggings. The men could not stand this very long, many became sick, so it was changed to take one Regiment at the time to remain fully dressed at the Alarm Houses. In the morning after Reveille the Regiment was ordered back into their quarters; according to order, this Regt. had to remain ready to turn out as soon as the pickets would be attacked.*[76]

The transcripts give firsthand account after account of the Trenton battle. Each soldier under oath answered questions about to whom the fault for the defeat could be attributed. Lieutenant Reinhard placed six cannons in front of Rall's quarters and described a picket at the "Docktor House," where a lieutenant and two men were forbidden to show themselves at daytime because of the American battery of heavy guns across the river. As soon as there was movement of the pickets, they were fired upon.

The examiners repeatedly asked if there was a warning that Trenton was about to be attacked by the "rebels." Lieutenant Reinhard answered: "A few days before news came from the inhabitants here that the Rebels were nearing and Col. Rall send [sic] the news to English to General Grant."

The soldier's testimony does not clearly state what happened, since he was dispatched to the bridge and to Bordentown. On duty together on Christmas Day were Sergeant Christian Diemer, age forty-two, a career soldier of twenty-seven years, from the Lossberg Regiment and the company of Major Hanstein, born in Buttlar, in the County of Ziegenhagen; and Ensign Jakob Zimmermann. Diemer testified that the main fort was the "Jäger House" and reported that his watch was with fifteen men patrolling the shore of the Delaware looking for an attack. He had first heard shots and then the cannons, and finally, after two or three hours, he was captured while retreating.

The stories of the troops reveal a state of confusion and the element of surprise. One young soldier, Friederich Frank Grebe from Rinteln (Hesse), only seventeen years old and a four-year veteran, testified that there was no contingency made by Colonel Rall in case of enemy attack and that, when it did come, he was forced to retreat from and surrender to what he estimated was the seven thousand rebel troops that had attacked at 7:00 a.m. The traditional tale told by the soldiers later on is that Rall surrendered to his own uncle, who had emigrated from the Rhineland and was a colonel in the American army.

Several soldiers were told of the mass confusion in the streets after the rebel attack: Corporal William Hartung from Elbingerodein in the Harz Mountains (twenty years old, with three years' service in the Hessian army and one in the Hannover cavalry); Second Lieutenant George Zoll from Riteln (twenty-nine years old, a twelve-year veteran); Ensign Frederick von Zengen from Bonenburg (nineteen, a four-year veteran); Captain Adam Christoph Steding, a widower from Fischbeck (thirty-nine, in the service for twenty-three years): Second Lieutenant August von Hobee from Mecklenburg (twenty-two years old, in the service since his sixteenth year); and Wilhelm Christian Moeller (Muller), a lieutenant from Ziegenheim (twenty-seven years old, ten years of service). They had heard reports of cannon fire and gunshots and were eventually confined by the Americans to a small space, where they were surrounded and taken captive.

Second Lieutenant Ernst Christian Schwalbe, a thirty-year-old from Rinteln with sixteen years in the service, reported:

> *A few days before the surprise came Doctor Brein to me at the Place of the Parade, he is the one to whom the so called Doctor house belonged, and he askt* [sic] *me for Col. Rall, who then could not be found; Doctor Brein then told me that he received information by a negro that the Rebels drew*

all the trupps [sic] *they could get together and intended to attack Trenton. Witness askt* [sic] *the Doctor to wait until Col. Rall came back but the doctor said he would call on Col. Rall in the afternoon when he would be at home. Col Rall thought very little of such news as witness often heard. The Doctor did really call on Col. Rall that afternoon and as it was much his own interest as it was the interest of the Garrison related the information received to Col. Rall. The Doctor was very much afraid of being robed* [sic] *and plundered and have his home burnt down by the enemy.*[77]

Ensign Friedrich Christian Henndorff, from Rheinfels, thirty years old, an eight-year veteran, testified that

the day before the surprise, has witness himself spoken to two deserters, who had also seen Col. Rall and then told the news, they told witness that Washington was crossing the Delaware to attack Trenton.[78]

Forty-year-old Captain Ernst Eberhard von Altenbockum, born in Courland, who had served twenty-two years, said that Colonel Rall had sent pickets out to the various landings on the Delaware:

Col Rall had the intention to capture General Washington at these landings. The enemy did effect a landing once, at the doctor House and Col. Rall supposed that Gen. Washington would come over himself and therefore was the whole Garrison put on the alert up to the last three days before the attack.[79]

He continued by answering a question about Colonel Rall receiving a warning before "the surprise."

It was allus [sic] *said that Col. Rall did not care for any such information. Witness heard Major von Dechow say on his death bed that Col. Rall had received a letter from General Grant* [the English general] *the day or two days before the attack telling him of the approach of the enemy and that attack was meant either from Princeton or Rall at Trenton and to be on his guard. . . .*[80]

The question was asked of this officer "Was not the picket that was posted near witness quarters attacked the evening before the surprise?"

The Captain answered that it was attacked at about 8 or nine o'clock in the evening, and went into Trenton proper to send reinforcements. After completing his journey and sending the men with aid back into the houses of

> *their quarters he went straight to Col Rall and found him with the rest of the staff officers at the head of the street near Rall's quarters, where he heard Major Von Dechow say to Rall, "We will have bad luck here yet, would it not be better of me send the baggage away towards the Grenadiers?" Col. Rall answered in a way which reflected his attitude toward the Americans, which he had acquired in the New York battles: "Humbug, the farmers want attack us, and if they do we will throw them."[81]*

Bombardier Conrad Volprecht, born in Schwage, forty-five years old, with twenty-eight years in the service, and Major Ludwig August von Haustein, born in Obernhof, a forty-six-year-old veteran of twenty-eight years, corroborated with the earlier testimonies.

Colonel Rall was found guilty of "mismanagement." Since this occurred a year and a half after his death, there was little to be done in his defense. The battle in these German documents is always referred to as "the surprise." Whether this "surprise" was because of Hessian ignorance, the bad weather or Washington's brilliance is hard to determine. The German soldiers were very young, and although they were experienced in some cases, the confusion of the final battle in the small streets of Trenton got about nine hundred men captured.

The attack was a total surprise; Colonel Rall's only fault in this battle was his ignorance of warnings that came to him, which he dismissed as improbable, and his total disregard for his enemy. *A German History of the American Revolution* depicts Rall's surprise awakening in a comically heroic fashion:

> *One hour after day break found the tips of the Americans on the sentinels of Hessian Billets. Cries of warning: "To the Guns!" were drowned out by the first shots and volleys. Drums and horns resounded through the streets. Colonel Rall, his night shirt, ran to the window and shouted "Was denn ist los?"* ["What is wrong?"] *In a moment Rall was dressed and mounted on his horse; a part of his regiment had gathered, and Rall began looking for a way to Princeton.*[82]

The miserable weather and the ice in the Delaware River caused the Hessian pickets to assume that the Americans would continue to skirmish and that no large assault would come. However, when it did come, the rain and snow caused the Hessian guns to misfire if they fired at all. The officers of the Von Lossberg Regiment fell or were captured first,

leaving the units in turmoil and confusion. Captain von Altenbockum, who reported the falling of the officers, was captured but escorted by an American officer to get his wounds treated.

The drunken Christmas celebration is a myth. These men, foot soldiers, many of them boys aged thirteen through seventeen, were exhausted, lacked sleep and were certainly not having a Christmas Eve party as they were rotated from watch to watch. The howling nor'easter allowed a respite for the men to rest. Colonel Rall was supposed to have, according to some, a hatred of his men and to have drunkenly played chess, checkers or cards when the battle came. He was engaged in a game; however, he had visited the outposts three times during the day. Washington was desperate and brilliant, and some believe that this battle was the turning point for the Americans. Historians who followed, including William Stryker and others, promulgated the myth of the drunken Teutonic soldiers who ignored the travails of George Washington and the "rebel troops." Much of the history was written without the input of firsthand accounts, which surfaced years later.

The "Convention Army"

Many American history textbooks omit the strange tale of the German prisoners, mostly from the Braunschweig or Brunswick Regiment in the "Convention Army," who marched across the state of New Jersey on to its final destination in Charlottesville, Virginia. Most Jerseyans have never heard of it or mistake it for another name for the American Continental forces. These soldiers left their mark both in legend and in settlements in New Jersey. Some of the stories still being told in the twenty-first century are oral history passed on by families whose ancestors settled there.

The story begins in the tiny German town of Wolfenbüttel near the larger home of the duke of Braunschweig, in the town that bears his family name. The landgrave Charles William Ferdinand, Duke of Brunswick, sent 5,723 men to the colonies to fight the "rebels." Remnants of the American conflict can still be found in the Braunschweig (Brunswick) archives housed in the old schloss, which was nearly destroyed by World War II bombs. It now has a modern shopping mall inside it. There are pieces of officers' shoulder board, scraps of Continental currency and colored pencil drawings of soldiers of regiments seen in Canada and America.

General Baron Friederich Adolf Riedesel (his full name was Friedrich Adolf Riedesel Freiherr zu Eisenbach) and his newlywed wife, Charlotte von Massow, lived in Wolfenbüttel. The baron, a member of minor German nobility, was stationed there as an adjutant to the duke of Braunschweig. Von Riedesel, born in Hesse, the second son of Johann Wilhelm Riedesel Freiherr zu Eisenbach, was destined for a career as a clergyman, lawyer or

Braunschweig Castle. *Photo courtesy of the author.*

Marburg Castle. *Photo courtesy of the author.*

Shoulder board from a Braunschweig officer in the American Revolution. *Stadt Archiv Braunschweig.*

diplomat. He was enrolled in the University of Marburg, where, instead of tending to his studies, he became fascinated watching the Marburg battalion of the landgrave of Hesse drilling. One of the officers literally tricked him into enlisting, at age seventeen, which was more to his liking than his indifferent success at his studies. His father disowned him but later on reconciled and sent him money in support of his rise to ensign. His first post for duty was London, where he learned to speak English and French. He was returned to Germany for the Seven Years' War, where he distinguished himself and rose to the rank of colonel in command of the Brunswickers (Braunschweiger) regiment.

Von Riedesel was wounded and then, like the plot of a German operetta, was nursed back to health by the woman he would later marry. The relationship was enduring, and there are records of their undying love for each other. Their bond was so strong that, when he was sent to the colonies, his wife, Charlotte, followed right behind him, in spite of her pregnancy and the small children she brought with her. When he departed for Canada with the German troops bound for the American conflict, he wrote to her:

> *Dearest wife, never have I suffered more this morning as I came away. My heart was breaking, and if I could have returned, who knows what I might*

Above: American money brought back to Braunschweig (front). *Stadt Archiv Braunschweig.*

Left: Continental currency (six dollars) brought back to Germany. *Stadt Archiv Braunschweig.*

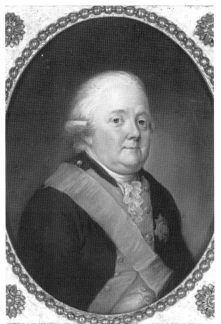 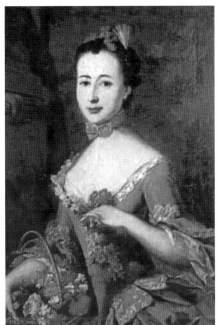

Left: General Baron von Riedesel, by Johann Heinrich Schröder. *National Museum in Warsaw.*

Right: Baroness von Riedesel by Johann Heinrich Wilhelm Tischbein. *Unknown location, public domain.*

> *have done. But, my love, God has given me this calling; I must follow it: duty and honor bind me to it, and I must console myself and not complain.*[83]

The general left from Braunschweig on February 22, 1776, for Stade on the Elbe with 2,282 men and 77 soldiers' wives. The rest of the units from Braunschweig joined in May, for a total of 4,300 men. Another 680 men from Hesse-Hanau joined them at Portsmouth. The Braunschweig soldiers were reviewed by Colonel Faucitt, who was not pleased to find old men and boys in the divisions. They were so ill equipped that the English government had to advance £5,000 to General Riedesel to get the men new uniforms and shoes in Portsmouth. Unfortunately, the English supplier took the money and ran, for there were no overcoats included, and the three cases of shoes, when opened, revealed ladies' slippers.

The fleet of thirty sailing ships finally left Portsmouth, England, on April 4 and, after a month's journey, arrived at Cape Gaspe on May 16. The fleet

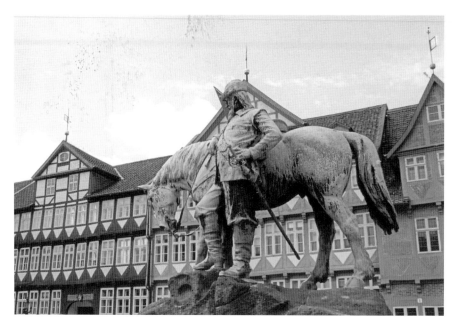

Wolfenbüttel Street, 2015. *Photo courtesy of the author.*

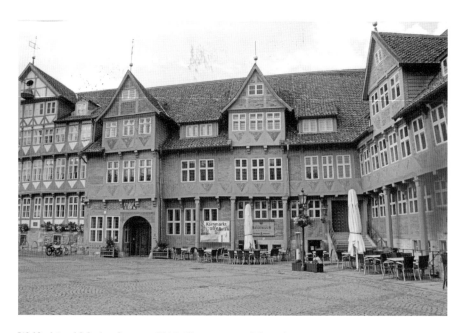

Wolfenbüttel Market Square, 2015. *Photo courtesy of the author.*

Wolfenbüttel Schloss, 2015. *Photo courtesy of the author.*

traveled on to Quebec on June 1, 1777. The journey was long and arduous. Von Riedesel wrote of the condition of his men:

> *The soldiers have almost all been sick and most of them continue to do so, as do also my servants. The poor cook is so bad that he can't work at all, nor so much as lift his hand. This is very uncomfortable for us, for Captain Foy and I have to do our own cooking. You would laugh to see us. Before the end of the voyage the drinking-water was foul.*[84]

Eventually, the rest of the Brunswick troops arrived in September with 2,000 soldiers. During the terrible sea voyage, 19 had died and 131 were sick with scurvy. They then found their way to General von Riedesel's forces along the Richelieu River, where they wintered as he drilled them to bring their marksmanship up to par with the Americans; the general had noted that the Americans were better marksmen.[85]

Meanwhile, Baroness von Riedesel decided to join her husband in the colonies. She was traveling with her daughters Augusta (four years and nine months old), Frederika (two) and baby Caroline (ten weeks) on a voyage that would take her to England, over the ocean to Canada and then to America. She wrote of the perils of the journey:

Muster paper for Braunschweiger soldier Johann Genning. *Stadt Archiv Braunschweig.*

I was told not only of the perils of the sea, but that we might be eaten by the savages, that people in America lived on horseflesh and cats. But all this frightened me less than the thought of coming to a land where I did not understand the language. However, I had made up my mind to everything, and the idea of following my husband and doing my duty held me up through the whole course of my journey.[86]

She traveled through England, where she had an audience at court, meeting and receiving a kiss from King George III. After many troubles and a difficult journey, the baroness was united with her husband, who was now under the command of General John "Gentleman Johnny" Burgoyne, whose plan, which he did not always share with his fellow generals, was to advance from Canada to Fort Ticonderoga in New York State and, after capturing the fort there, head south toward Albany.

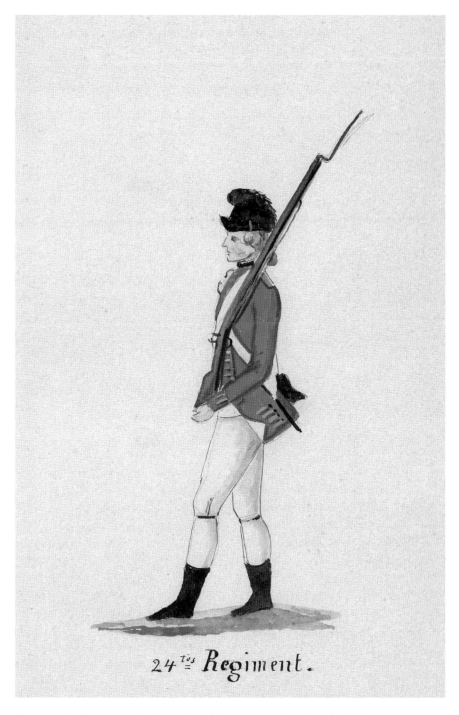

Drawing of a Braunschweig Twenty-fourth Regiment soldier. *Stadt Archiv Braunschweig*

There, his forces would meet the army of Sir William Howe coming up from New York.

A unit commanded by Colonel John Leger was to operate with Burgoyne and meet him up the Hudson above Albany. General von Riedesel found the English commander hard to deal with, as he generally kept strategy and troop plans to himself, expecting the rest to simply follow his orders. In addition, "Gentleman Johnny" was more interested in his personal pursuit of pleasure and entertainment, a quality that did not meet with the expectations of the German staff.

On the first day of June 1777, there were 4,300 officers and men under Riedesel's command, of whom 3,958 were considered the "effective strength." There were also 668 Hesse-Hanau soldiers, bringing the total number of German auxiliaries in Canada to 4,558. Burgoyne commanded the majority and Sir Guy Carleton the smaller remainder of the larger body. In total, Burgoyne commanded nearly 8,000 soldiers. About 500 Native Americans accompanied these units as scouts. Their other task was to scalp rebel soldiers—a procedure Burgoyne thought would be a good method for dealing with deserters.[87]

When the British army, accompanied by von Riedesel and the Brunswickers, reached Fort Ticonderoga en masse, the American commander Major General Arthur St. Clair realized that he needed to rapidly retreat from the fort, which had been improperly prepared for defense. In the mêlée, St. Clair was forced to leave seventy cannon behind for the British, along with two hundred head of cattle and a storehouse full of ammunition and provisions.

St. Clair counterattacked by ambushing the British and Germans who were following him. In the process, he lost about two hundred men. The Americans abandoned Fort Anne on July 8, leaving it in ruins. Von Riedesel warned his men against stealing and plundering and offered a beating for a first offense and running the gauntlet four times for a second offense. Burgoyne took a month to follow the American army, because the Americans had felled large trees across the pathways in the midst of the heavy forests to hinder the British. The other daunting task facing the British forces was the reconstruction and repair of over forty bridges destroyed in the Americans' retreating path. Burgoyne wrote to Riedesel on July 18, asking him to have the officers reduce their baggage.[88]

The British and German troops were finally headed for Manchester, but Burgoyne sent them instead to Bennington, Vermont, deciding that the Americans stored food and ammunition there and that the British army badly needed those supplies. Burgoyne marched to Stillwater, New

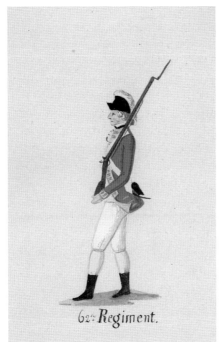
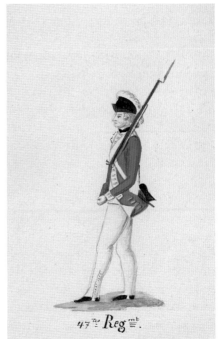

Left: Drawing of a Braunschweig Sixth Regiment soldier. *Stadt Archiv Braunschweig.*

Right: Drawing of a Braunschweig Forty-seventh Regiment soldier. *Stadt Archiv Braunschweig.*

York, and to Bemis Heights to attack the forces led by General Benedict Arnold. On August 11, 1777, Lieutenant Colonel Baum marched toward Bennington with 550 men, of whom 374 were German and 150 Native American. Burgoyne and Baum wanted the supplies, and they believed that the town of Bennington was only lightly defended, unaware of General John Stark and 1,500 American militia stationed there. The ensuing battle, toughly fought by the colonists, was a disaster for the British forces. General Baum lost his life, and 700 prisoners were taken by the Americans, including 400 Germans. The British forces suffered 231 killed, wounded and missing. Most of the Native Americans left; Burgoyne's army was reduced by 1,000 men at that battle. Burgoyne set out to aid General Baum and followed with his regiments, but it was in vain.

These losses and the condition of the army led to Burgoyne's defeat in the battles that followed. There were few provisions; uniforms and clothing were torn and tattered and were not replaceable. There were supposed to be twelve thousand colonial troops in the area, so Burgoyne

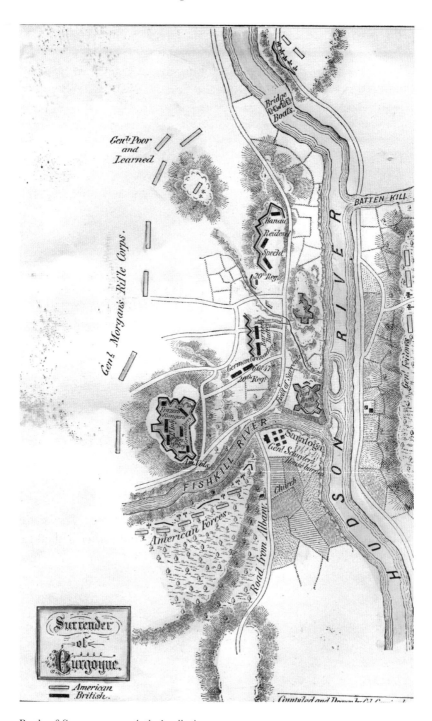

Battle of Saratoga map. *Author's collection.*

sent for help to the British general Sir Henry Clinton. The message, encased in a silver bullet, landed in the hands of the American general James Clinton. No help was forthcoming, and then the rations ran out. He had hungry soldiers who started to desert, and no punishment could hinder the departures. From September 19 until October 7, the British units were engaged in a series of conflicts that came to be known as the Battle of Saratoga. American forces under the leadership of Benedict Arnold decisively defeated the British at every turn. The upper echelons of the British army decided to retreat, as they were now surrounded by the stronger American forces. The foot soldiers were hungry, tattered and exhausted—the decision to "capitulate" was made. This surrender had to be honorable at all costs. The negotiations went back and forth between the chiefs of staff.

> *Burgoyne's proposals, which were in substance that his army should yield themselves prisoners of war, but under condition that they should be taken to Boston and thence shipped to England, agreeing not to serve against the Americans during the war, unless previously exchanged.*[89]

The American general Horatio Gates did not accept this proposal but responded:

> *General Burgoyne's army being reduced by repeated defeats, by desertion, sickness, etc., their provisions exhausted, their military horses, tents, and baggage taken or destroyed, their retreat cut off, and their camp invested, they can only be allowed to surrender as prisoners of war.*[90]

Eventually, the "surrender" was arranged. The defeated British army did not want to be called the "surrendered army," but rather wished to be known as the "Convention Army." And so it was called. This "capitulation" was described in the following terms:

> *Five thousand seven hundred and ninety-one men were included. It is stated by Riedesel that not more than four thousand of these were fit for duty. The number of Germans surrendering is set . . . at two thousand four hundred and thirty-one men, and of Germans killed, wounded, and missing down to October 6, at one thousand one hundred and twenty-two. The total loss of the British and their mercenaries, in killed, wounded, prisoners, and deserters, during the campaign, including those lost in St. Leger's expedition*

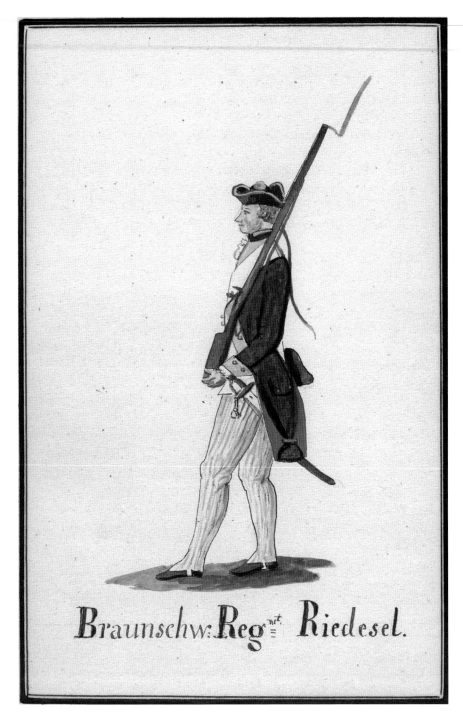

Drawing of a Braunschweig Company Von Riedesel soldier. *Stadt Archiv Braunschweig.*

to the Mohawk and those who surrendered on terms at Saratoga, was not far from nine thousand.[91]

On October 17, with accompanying ceremony, the German Brunswickers and the soldiers from Hesse-Hanau were officially "prisoners of war." What was to become of them? The Continental Congress wanted to keep them in America. Their own duke of Brunswick didn't want them to return.

On receiving the news of the capitulation of Saratoga, the minister of the Duke of Brunswick wrote to the English commissioner that those men who had surrendered ought not to be allowed to return to Germany, lest they should be discontented and discourage others from enlisting. Send these remnants to one of your islands in America, place them in Europe in one of your islands, like the Isle of Wight. On no account were the poor devils to be allowed to come home.[92]

General von Riedesel, despite the surrender, would not give up the colors of the Brunswickers; he had the wooden staffs burned, and his wife sewed the banners up in a mattress and had them smuggled into New York City to be returned home at a later date. The original idea was to return all the personnel to England; that notion was cancelled because of the American fear that these soldiers would return, so they were sent to Cambridge, Massachusetts. After a year of foraging and looking for food, when the Congress decided that they were to be marched to Charlottesville, Virginia, they left. In November 1778, the Brunswickers, accompanied by

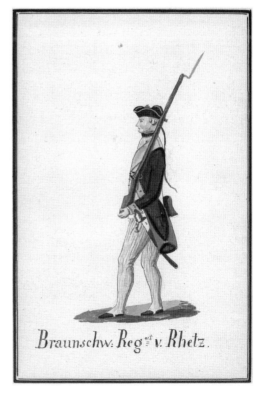

Drawing of a Braunschweig Company Von Relz soldier. *Stadt Archiv Braunschweig.*

Left: Drawing of a Braunschweig Leichtes Infantry Battalion soldier. *Stadt Archiv Braunschweig.*

Right: Drawing of a Braunschweig Regiment Von Specht soldier. *Stadt Archiv Braunschweig.*

American guards, straggling Native Americans and camp followers, began an unusual journey. They were hungry and poorly clothed, and many had no shoes. Food was scarce and needed to be obtained along the march. Nevertheless, roughly five thousand to six thousand people started out. Each regiment was sent one day apart, the idea being that the space of a day between the separate units would prevent mutiny and desertion.

A ragtag mob of people trudging along the roads would certainly draw attention. At this point in the war, if a soldier deserted, he would be sought out and executed. Frau von Riedesel found a comfortable English carriage for her husband, who was often sickly, and her three small children. On the way, she met the poor as well as the rich and famous; she kept a diary of her observations.

The Convention Army traveled through Massachusetts into Connecticut and then New York State, following the route from Fishkill to Newburgh and through Goshen and Florida to Warwick. There, it crossed the border into New Jersey through the town of Sussex and then to Old Court House (today's Newton) and through the little towns of Stillwater, Log Gaol (Johnsonburg)

Hessian House in Stillwater, New Jersey. *Photo courtesy of the author.*

and Hackettstown. It then moved through German Valley and eventually into Pennsylvania and on south through Maryland and finally to Charlottesville, Virginia. The baroness wrote very detailed accounts of the journey; she was a very social person and enjoyed dining with generals and local politicians. Rural New Jersey did not hold the same charm as elegant Virginia, so she never mentions it. Could she have been protecting the soldiers who left the army on the route? Maybe she did.

Thomas Anburey in his letters relates a tale of the plundering by German troops told to him by a Loyalist farmer, who had moved into Sussex County, New Jersey, from Trenton:

> *British soldiers only pilfered poultry and pigs, but the Hessians entered, broke open drawers, taking away plate cloathes, and other valuables.*[93]

There are stories among the people of Sussex, Warren, Hunterdon and Mercer Counties about the "Hessians" who marched through 230 years ago. There are rumors about deserters who were hidden and their names changed for protection. For example, twelve "Hessians" deserted in Stillwater, New Jersey, with only the name John Kaspar Losey mentioned as a member of a Hessian regiment; the remaining eleven soldiers' records were lost or

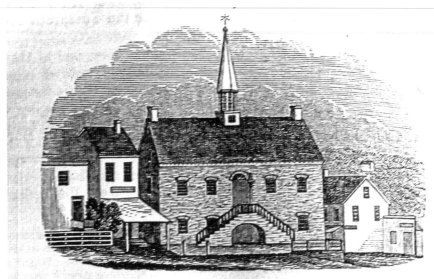

View of the Courthouse, Newton.

Old Court House, Newton, New Jersey, as the Convention Army saw it. *Collection of the author.*

The Caspar Schaffer House, Stillwater, New Jersey, circa 1748. *Photo courtesy of the author.*

Hope, New Jersey; a Moravian community. *Photo courtesy of the author.*

never written down. In Germany during this period, there was a practice of punishing those who hid deserters, and the German American residents thought that the same could happen to them. German prisoners who tried to escape could still be shot, and many Sussex and Warren County residents were Loyalists who would "turn in" a deserter. The colonies welcomed the deserted soldier, even to the point of offering a land reward after the war in return for military service. The German people of these farms and small settlements along the route were from the Palatine region, or Rhineland, of central Germany. Some were related, and some found friends; however, the danger of being turned in resulted in many a name change.

The anti-German feeling after World Wars I and II produced a submersion of German American culture. The Hessian House in Stillwater owned by a German family had the historic sign removed during this period. German Valley was renamed Long Valley, and New Germantown became Oldwick, New Jersey. The worst offense was the removal of forty-five Hessian soldiers from their graves during World War I. They were tossed unceremoniously in the Hudson River by "patriotic" citizens.

In the Green and Frelinghuysen area of New Jersey, the farmers tell the story of the Hessians promising not to burn the wooden fences of the pastureland for firewood, if only they could have some beef. Baroness von

Riedesel observed that there was a scarcity of firewood that winter; therefore, the chestnut, hickory and oak fences of the countryside were an easy source of firewood. Baroness von Riedesel's diary is the only descriptive account of this Convention Army's journey; however, little is said by her about the foot soldiers' travels through this part of the countryside. She does describe the condition of the troops as they were left after the surrender:

> *The uniforms that had been worn through a hard campaign in the wilderness hung in rags on the freezing soldiers. They cut off the tails of their coats to make patches for the rest of their clothes.*[94]

The result of each regiment's staggered release from Cambridge was a long line of haggard soldiers, ill dressed and speaking to each other in a foreign guttural tongue. They were accompanied by mounted officers and the carriage of General von Riedesel and his family. They reached New Jersey and may have followed the Hessian map of 1777, designed to show the redoubts in northwestern New Jersey.[95] These maps list the old names of the towns and even include the name of a German farmer, Caspar Shaeffer, in Stillwater, New Jersey. The army's route can be followed today; amazingly, some of the original houses on the way are still standing. The journey through the county took two weeks, passing through the towns of Sussex, Hardyston, Newton (then Old Court House), Andover, Hackettstown, Changewater, Pittstown and Everittstown, with desertions at each stop.[96] The dwellings were far apart on the way, and if residents encountered the captured soldiers, nothing is written about it. The modern historian has overlooked this forced march primarily because there is little archaeological or documentary evidence of the trip.

There is a description of their march across Massachusetts in October 1777:

> *In some places the inhabitants refused to take the prisoners into their houses, and in other places, where it was necessary to halt, there were not houses enough to hold them. The inhabitants, on their side, complained that the passing prisoners burned their fences, destroyed their fodder, and stole clothes and furniture from their houses. From all sides the country people flocked to see the prisoners, and pressed into the houses where they were quartered, until the officers began to think that their landlords took money for the show.*[97]

The areas of New Jersey where these troops stopped and camped are unmarked; whether or not they stayed with farmers is not recorded. The

possibility exists that while the war was still on, contact with enemy soldiers was considered disloyal and dangerous. On the other hand, this part of New Jersey never saw any Revolutionary War battles, only regiments passing through and raids by the local Native Americans. There are oral histories that tell of deserters from the "Hessian" army changing their names and becoming farmers in the area. However, because of World War II "Bundt" meetings and camps in Andover and Newton, New Jersey, the image of the passing German soldier remains largely negative, evidenced by a local drama produced in the 1970s. The one positive viewpoint of a local author is in a book called *The Story of an Old Farm, or Life in New Jersey in the Eighteenth Century*,[98] by Andrew Mellick Jr., who was a descendant of an early German immigrant from Bendorf, Germany.

Only two thousand men reached the destination in Charlottesville, Virginia—about four thousand deserted or died on the journey. One legend continues to surface about one of the deserters and his descendant. There is a tale that a member of the Von Lossberg Regiment in the Convention Army, Reinhold Küster, a foot soldier, was captured in 1777 by General Gates. He was imprisoned and then deserted from either Lancaster, Pennsylvania, or Pompton Plains, New Jersey, en route. He eventually moved to Maryland and was the father of the "Custer" family and the great-grandfather of General George Armstrong Custer. This rumor, like others, may have some foundation in fact; however, no genealogical records are extant that would substantiate this connection.[99] Records of the deserters from the Convention Army are sparse, and accounts live on only in conversation. Those men who died were buried in unmarked graves like other German soldiers.

The von Riedesels fared better than most. The baroness found a horse and carriage for her family and the general, who suffered from nervousness and chronic illness. They then traveled to Virginia, accompanied by an American officer named Captain Browne (probably James) appointed by American general Lord Stirling to tend to the family.[100] They arrived in Charlottesville to find that the only shelter were cabin walls that were roofless and covered with snow. Thomas Jefferson intervened, and the von Riedesels were housed in Colle near Charlottesville, in the house of Phiilip Masei, who was in Europe on an American diplomatic visit.

The other soldiers were allowed to construct their own shelters; in typical German fashion, they constructed a neat village that included stores and ample housing. Thomas Jefferson was trying to learn German, and as a result of his love of music and language, he played violin in a string quartet with the German "prisoners." Frau Baroness von Riedesel became friendly

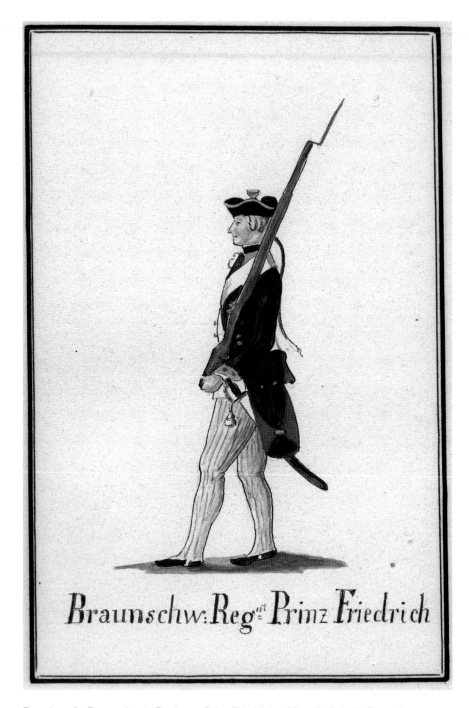

Drawing of a Braunschweig Regiment Prinz Friedrich soldier. *Stadt Archiv Braunschwe.*

with Mrs. Jefferson and taught them all to dance. She also shocked the local populace by refusing to ride sidesaddle, choosing instead to ride astride! Jefferson was criticized for his involvement with prisoners:

> *He busied himself with the problems of the war prisoner making suggestions for vegetable planting and barracks buildings and the officers and men in their wretchedness. He fraternized freely with the German soldiers, discussing philosophy with Captain John Ludwig de Unger and Baron Friederich von Riedesel. He played duets with Baron de Geismar, arranged living quarters for Baroness von Riedesel when she joined her prisoner husband, and shared with them both the hospitality of Monticello. Eventually he sold his pianoforte to von Riedesel for £100.*[101]

The von Riedesels took side trips to the local spa for his health; she journeyed to Bethlehem, Pennsylvania, for a six-week stay with the Moravians at the Sun Dance Inn. The general, still suffering from ill health, was paroled to New York in 1779 and from there was sent to serve in Canada, where the family remained until they returned home to Germany and Wolfenbüttel. The baroness's diary provides information and closure to their long wartime journey, leaving a description of the trials and tribulations of the German soldiers.

THE HESSIANS AND THE IRON MASTERS IN NORTHERN NEW JERSEY

According to a newspaper article in the *Newark Daily Advertiser* in 1851, during the Revolutionary War there were between eighty and one hundred ironworks in Morris County, part of the rich iron-mining industry in Essex, Sussex and Passaic Counties. These mines and furnaces stretched along the countryside in the more mountainous areas of northern New Jersey, and many of them were German owned or operated. Their history is long and interesting, with enough material to fill a book on their production, ownership and the famous characters attached to them. Their continued production of ammunition was very important to the Continental army.

The rich iron-ore deposits extend from the northern part of the state in Mahwah, through Rockaway, Randolph and Mine Hill to Union County in central New Jersey. One of the earliest was the Long Pond (now Greenwood Lake) mine. The London Iron Company contracted a German-born British citizen, entrepreneur Peter Hasenclever, to open the Ringwood Iron Works and mine and import 535 German men, women and children to work in them. Descendants of these workers are puzzled as to their ancestry prior to their ancestors' arrival, for there are no records of their arrival other than that of entry into Philadelphia. The question remains: Were they indentured servants or not? These people were imported from the Palatine region, including Barenberg (now Wuppertal), Ronnsdorf, Bruhl and Elberfeld, although some may have been from southern Germany. They sailed up the Rhine River to Rotterdam and then on to Philadelphia. At this time, Germans were not

welcome in New York. The Rhode Island *Providence Gazette* published an article on October 13, 1764:

> *At a time, when a new System of Regulations in Commerce, our Trade is oppressed and restrained, and our spirits sunk to a new Ebb, as by natural Consequences our Purses must be by and by, Providence seems to alleviate our Pains, by sending Peter Hasenclever, a public and noble spirited Stranger amongst who last Week introduced into the Province, at an immense Expence, above 200 German, (Women included) consisting of Artificers, as Miners, Founders, Forgers, Colliers, Wheelwrights, Carpenters, &c. There never was brought a finer or more valuable, set of People to America, than these by which means our Trade and that of our Mother Country, must be considerably augmented, particularly as Mr. Hasenclever's Schemes do not interfere with the manufacturing part of England; but on the contrary, tend to increase the English Manufactories, as he only employs his men to dig the Prima Materia out of the Bowels of the Mountains, as Iron, and other metals, and prepares them fit for Work. WE [sic] have the Pleasure to assure the Public, that his People have begun to work, with great Success and that he has the Wishes and Thanks of well-intentioned Patriots.*

Peter Hasenclever, born in Portugal, hatched a scheme in 1745 to gather money for the opening of mines and the production of ore and potash, which could be purchased to export to England using monies from the sale of fresh cargoes of merchandise from the West Indies. The idea needed an immense amount of capital; Hasenclever never had trouble raising money and accumulating investors, and this time he used funds supplied by the courtiers and ladies-in-waiting at the court of George II.[102]

The mines were operated by German laborers for the London Mining Company. One of the managers, John Jacob Faesch, was brought to New York on October 1, 1767, by Hasenclever from Hesse-Cassel as an indentured worker. Faesch left the company in 1772 and purchased six thousand acres of land covering the Mount Hope Tract in Rockaway, New Jersey. The blast furnace that he built there became vital for the production of ammunition during the American Revolution. In 1773, the Hibernia Mine, several miles away, was purchased by Lord Stirling and managed by a German immigrant named Joseph Hoff. The needed workers were obtained locally by newspaper ads[103] that listed the pay for woodcutters at three shillings per cord, along with the promise: "Whoever inclines to work, at this pace, may depend on

meeting with civil treatment, honest dealing, and punctual pay." There is an insinuation that other mining companies did not deal honestly or pay on time.

William Alexander Lord Stirling, engraving by Harper and Brothers. *Public domain.*

Peter Hasenclever's workers were indentured, which meant no pay for several years. They suffered abusive treatment on the job and were not able to leave the employ of one mine to go to another. If their only goal was to get to America, they deserted once they arrived. Hasenclever had a great deal of trouble from 1765 to 1767 with desertions and infighting between the miners and other workers.

On or about June 21, 1767, the *New York Journal* reported:

> *We hear from Ringwood Iron Works, in New Jersey, that last Week, a Fray happened among one of the Workmen of that Work, which continued some Time, by which one Man Lost his Life and several were badly wounded.* [104]

The reported fracas was only a part of Hasenclever's troubles with this mine; by 1773, he was in financial difficulty with the London company, which was asking for profit and a return for the investors. The July 10, 1773 *New York Gazette and Weekly Mercury* published a letter from the newly appointed mine manager, Robert Erskine:

> *How is it possible then the books could be otherwise than cooked that the money can be fairly accounted for, or that Mr. HASENCLEVER has least shadow of right to charge the experience of all his mad projects to account of the proprietors of the iron works, in several of which they have no share, and many of them I suppose, never came to their knowledge.*

Hasenclever was called back to London to explain the financial status of the mining operations, but he went on to Germany to avoid the confrontation with the company and the repayment of investments. Robert Erskine became the manager of the mine. Hasenclever was a Loyalist supporting the Crown that had financed his efforts. Erskine, a Scottish inventor and engineer, organized his workers into an American militia at the start of the Revolution and rose to the rank of colonel. General Washington appointed

him geographer and surveyor general of the Continental army and made him his aide.

When the Revolution began, all of the mines, including the three in northern New Jersey, were shorthanded. As the need for ammunition increased, the labor force became even scarcer. Richard Henry Lee wrote to Washington on April 16, 1777, requesting exemption from the military for the ironworkers:

I would therefore submit it to your consideration Sir, whether (until the Legislatures can provide competent laws) it will not greatly remedy the evil, if you were, by order published in all the papers, [to] forbid all Continental Officers from inlisting persons engaged with, and actually serving in any iron works within the United States, or from pressing any horses, teams, or Carriages of any kind belonging to such works.[105]

George Washington replied to Lee from Morristown on April 24–26, 1777:

You are not aware of the evil consequences that would follow a general exemption of all persons concerned in Iron Works from Military duty, they are very numerous, and in this part of the Country form a great Majority of the People. Besides, why should the Iron Master carry on his Trade without restriction when the Farmer equally useful for the Support of the War, the Shoemaker and other Manufacturers absolutely necessary to the equipment of an Army, may have their Servants & Apprentices taken from them at pleasure? One thing I have ever done; and it has, I believe, answered the end proposed by you. Whenever an Iron Work has been Imployed for the Public I have desired the owner to give me a return of the number of Men, and the names of those necessarily Imployed therein, and have exempted them from the duties of Militia men in this State—this I have found necessary to do on two Accts—first to secure such Articles of Manufacture as the Army wanted; and next, to prevent numbers under this pretext from withholding their Services in the Military line—there being in this County (Morris) alone, between Eighty & a hundred Iron Works, large & small.[106]

When the suggestion to use German prisoners of war to work in the Hibernia and Mount Hope Mines was made, John Jacob Faesch in Mount Hope saw the solution as a perfect fit. He was born in Hesse-Cassel, and his wife was born in Bendorf on the Rhine, which was an ethnic connection to both the local German population and the Hessian prisoners of war. Faesch, the owner, lessee and manager of both mines, was originally imported to

Long Pond Iron Forge. *Photo courtesy of the author.*

manage the Ringwood Mining works. He moved to Mount Hope, where he leased the mine and house from Jacob Ford Jr. At the time of the Revolutionary War, Faesch owned it outright or with partners, including the Brookland, Mount Pleasant and Longwood Furnaces. Charles Hoff, also of German descent, was the manager of the Hibernia Mine. His marriage into the prominent Tuttle and Ford families influenced his apprenticeship to Lord Stirling, which led to his position when his lordship became one of Washington's generals.

Large amounts of ammunition, including shells and cannonballs, were produced by these forges, one of which remains as a museum on the grounds of Picatinny Arsenal. There was a growing fear of an attack on these munition-producing furnaces by the British and Hessian troops in New York. Washington was again petitioned to let able-bodied men stay at the forges instead of going into the military; however, by this time Congress promised free land to anyone who enlisted in the Continental army.

David Ford, returning to the mine area on June 1, 1780, wrote to John Jacob Faesch that he believed the British were on the march in Elizabeth and that he was worried about an attack. He wanted Faesch to gather some men and protect the forge at Rockaway. His warning was followed by a letter from Charles Hoff, manager of the Hibernia Mine, on July 27, 1780:

Hastily written note to John Jacob Faesch.

Hibernia 27ʰ July 1780

Sir,

Received your note of the 25ʰ Instant and in answer thereto, I would just inform you, we are just going with Blast to Cart a large quantity of Shells for the Continent; I have a Captain and twenty men to guard the Works, that by Order of General Washington have exempted from Military Duty by a committee of Congress, which Governor Livingston is fully acquainted with; and that the consequence of our Business, is of the greatest Importance, and was it not for the assistance of the Soldiers, and the Mount Hope people, it would be out of our power, to serve the Publick in this way we are greatly in want of hands, would take it kind of you to send us some; you will see by the forgoing part of this letter it is entirely out of my power to send the two men requested and do the publick a greater piece of Service.

I am your humble servant
Signed: Charles Hoff Esq. [107]

In 1799, there were one hundred workers, including women and children, at the mine, which consisted of four shafts, with two laborers working each

Long Pond Iron Works from the American Revolution. *Photo courtesy of the author.*

one. There was need for more labor than it took to mine the ore because of the need for wood to produce charcoal. Fourteen cords of wood were needed to burn for charcoal, which would produce one ton of iron. In March 1782, the works could produce two tons of shells per day.[108]

Although local legends in Morris County speak of 250 Hessians brought north by George Washington, 35 men are the only ones on record at the Mount Hope arsenal; there is a report of the use of Hessian prisoners to manufacture camp kettles and shot.[109] Although Faesch is listed as a Swiss national in the *Morris County History*[110] (perhaps a cover for patriotic and anti-German feeling), it would make sense for him to gather his countrymen from central Germany, who understood his dialect rather than Schweitzer Deutsch (Swiss German), which he would speak if he were a Swiss native. His handwriting in the old German script and his word choices indicate a Hessian background.

Faesch needed woodcutters badly, since the furnaces were kept burning day and night; therefore, he went to Philadelphia on April 28, 1782, to the jail that held captive German troops. He had contracted with the board of war for their release to him at the rate of three shillings, six pence per cord of wood, a good salary at the time, and more than the Pennsylvania ironworks were paying. The thirty-five men were delivered by Captain Harry "Lighthorse" Lee of Bernardsville, whose son Robert commanded the Virginia military in the Civil War. Faesch requested the following:

> From 15–25 good men, such as above, particularized for iron works; a good blacksmith; a good wheelwright; 1 or 2 good carpenters, and 1 or 2 good masons; one instructed in the first number. . . . Let all or as many as possible be Englishmen or can speak the language. First every man brings his blankets, knapsack. They must be messed 4 or 6 men together and board themselves. They will be found good provisions, which they must buy and expect to pay for out of wages.[111]

The requirements were the same for the Mount Hope and Hibernia mines. Most of the Hessians were from the Von Knyphausen Regiment, captured at the Battle of Trenton in 1776 and exchanged in 1778. In September 1779, they left New York on a ship bound for Quebec; however, two of their ships were captured and they were prisoners for a second time (December 1780—April 1782). Faesch's success in obtaining these workers was due in part to the preference of the military for the north New Jersey shells over the Pennsylvania version and the fact that he was fluent in German

and a "landsman" (countryman). Quartermaster Timothy Pickering wrote in 1780 to the chief of artillery, Henry Knox: "Damn the Pennsylvania made shells, they are poor and vary in weight, and Faesch's are almost perfect."

The thirty-five men he "hired" were:

Regiment von Knyphausen

Leib Company
Corporal Conrad Daube
Private Justus Heinrich Gleubert
Private Johannes Wiest
Private Paul Haust
Private Henrich Gimbel
Private Wilhelm Steinbrecher
Private Andreas Pfeiffer
Private Georg Henrich Schneider
Private Curt Conrad
 Company von Biesenrodt
Private Johannes Engeland
Private Georg Schmidt
Private Henrich Priester
Private Conrad Corell
 Regiment Erbprinz
Private Adolph Assmann
Private Leopold Zuendel
 Hesse Cassel Artillery

Company von Borck

Corporal Nicholas Fenner
Private Hinrich Schultheiss
Private Claus Henrich Müller
 Company von Dechow
Corporal Philip Roether (Roeder)
Corporal Johannes Wohlgemuth
Corporal Jacob Goercke
Private Hinrich Plättner
Private Hinrich Schnuecker
Private George Hahn
Private Johannes Wilke
Private Valentin Landau
Private Hinrich Quehl (Quaehl)
Private Hinrich Angersbach
Private Sigmund Präsler
Private Wiegand Dolland
Private Dietrich Schultheiss
Private Johannes Speichert
Cannonier Jacob Peter

Hesse-Hanau Artillery Bombadier Wilhelm Liest
(List Cannonier Peter Eichman)[112]

There are old stories about these prisoners being housed in the basement of the Faesch house or in a prison built for them. They were well fed by the Continental army. Problems arose when General Moses Haren sent Captain Anthony Selin and Lieutenant Benjamin Moorers to recruit these workers into the American army. At this time in the war, the German prisoners could either enlist or buy their way out with $80.00 (£30.00 in Pennsylvania or New Jersey currency and $1,124.44 today). Another option was to become indentured for three years to any New Jersey citizen willing to pay the price. The agreement they made with Faesch was to be paid on a daily basis, with food and clothing costs deducted from it. Faesch took it to mean partial payment with the rest to be paid by indenture when the war was over. Toward

the official end of the war, in February 1783, and as a result of impending indenture, the German prisoners made an attempt to escape to New York. They only got as far as Newark, where they were captured and held in jail without food for eight days. Faesch bought their freedom, paying $20.00 for each man (to be deducted from their wages). On March 7, a recruiter visited again, threating that they would be returned to Philadelphia if they did not enlist. Despite harsh methods, including being jailed in Pompton Lakes with no food again and threatened with a sword to the chest, they did not enlist. Faesch offered £30.00 for them; they had no choice but to accept. On March 12, they were made to swear that they would either repay or work for the money. On March 19, they heard that hostilities had ceased and prisoners were to have their liberty. Faesch, however, published an ad in the *Philadelphia Newspaper* in April 1783, reprinted in the *Boston Evening Transcript* in April 1864:

> *Ten Dollars Reward*
> *TO THE PUBLICK*
> *The subscriber some time ago, agreeable to a*
> *Resolution of Congress, contracted with the board*
> *of War, for thirty five Hessians to serve him for*
> *the term of three years, upon the terms of the*
> *said resolve.*
>
> *And, whereas he has reason to believe they*
> *will attempt to avail themselves of the indulgence*
> *of the times, and desert from the service, passports*
> *Being no longer demanded, he therefore requests,*
> *That agreeable to his advertisement some time*
> *since published, should any of said Hessians em-*
> *ployed at this works, be found more than three*
> *miles distance without a written*
> *pass signed by him, they may be stopped and se*
> *cured, he will pay with cheerfulness TEN DOL*
> *LARS and all reasonable charges, for every man,*
> *Who shall be taken without such pass as afore*
> *mentioned, to any person or persons who will confine*
> *him or them, in any gaol with in this State, or re*
> *turn them to the works of the publick's much*
> *obliged, and most humble servant*
> *JOHN JACOB FAESCH*[113]

When a peace treaty was signed on November 30, 1782, the workers at Faesch's mine petitioned Lieutenant General de Lossberg for release. It took fourteen months for them to be let go. The conflict came from Faesch's belief that the prisoners still owed him time or money, based on a proclamation of July 30, 1782, by Captain Thomas Bowen of the Fifth Pennsylvania Regiment in Reading:

> *The King of Great Britain has refused to support exchange you, as prisoners of War; and the Congress of the United States of America, in Commiseration of the Sufferings occasioned by your long Confinement, has put it into your power to become free Citizens of this free and happy Country, and for this purpose have made you the following Proposition.*
>
> *In the first place, Congress demands of you, the sum of Thirty Pounds, as a small consideration of your long Support, or to find a person to pay that sum for you.*
>
> *The 2nd Consideration frees you from this Debt contracted for your subsistence, by inlisting yourself into American Service, and that in either case you do take the Oath of Allegiance to the United States.*
>
> *That they had to serve three years indenture or buy their freedom for £30. The prisoners believed that the war was over and they should go home.*[114]

Above and opposite page: Continental money (thirty dollars) brought back to Germany. *Stadt Archiv Braunschweig.*

They could still have enlisted in the American army and gotten eight dollars to drink to the new country and one hundred acres of good land. The Mount Hope prisoners felt that they had paid for their food and clothing and had done their time. They also felt that they had been abused by Captain Anthony Selin, a Swiss German-speaking American officer who was trying to recruit them for his American Jäger Company, Ottendorff's Corps, made up primarily of German Americans. Letters flew back and forth at the highest levels. Moses Haven wrote the following to General Benjamin Lincoln:

> *Agreeable to your directions, I have inquired into the complaint made by the Germans at Mount Hope, and it appears to me to be altogether without foundation and the least colour of truth. General Von Lossberg got into the battle of the letters. The Hessian prisoners wrote letters of weeping families at home and the need for funds to buy their freedom. Only two of them, Valentin Landau and Jacob Peter were able to buy their freedom, and they headed straight for New York to give their side of the story to General von Lossberg.[115]*

Their trip had made an impression and caused the general to send Major Carl Leopold Baurmeister to travel and round up the former prisoners of

war. He found 345 of them in the Pennsylvania area and reported that few wanted to return home. The German soldiers could be allowed to remain, but the British had to return home. Baurmeister met with Faesch in New York and found that the agreement between Faesch and the prisoners had been bargained solely between them and was exclusive of other military and private arrangements for labor. Faesch agreed that if the remaining debt could be paid to him, he would release them; if not, he would let them go at the end of the year without further compensation.[116]

Baurmeister decided to go to Mount Hope and agreed to pay the rest of the indenture; to his surprise, when he arrived, there were only twenty-seven men left. Two had worked themselves free and were living in Philadelphia; the rest had escaped. Von Lossberg asked Faesch to prepare a detailed statement of what was owed him, and the men were released after fourteen months. On August 8, Lieutenant Unger went to Mount Hope to get the remaining Hessians. This time, there were twenty-one left; the rest had decided to stay in New Jersey.

The records of those who stayed are sparse, and the known settlers appear to be Adolph Assmann (listed as a deserter), Leopold Zindel (listed as Johannes Zindel) and possibly Georg Schmidt (who founded Smith's mill in West Milford). The rumors about these men and probably others are still being told. There is a cemetery in Picatinny Arsenal called the "Hessian Cemetery." It is very close to Faesch's Mount Hope works. There are no headstones, and in the whole graveyard there are three stones, all from the Revolutionary War period. Stick markers placed there when the cemetery was restored show many more interments.

There is a story that George Washington released Hessian prisoners on the corner of Openaki Road and Mountainside Drive on the Randolph-Denville boundary in Morris County. Mountainside Drive was an old stagecoach route that leads down to a farm built in 1751; the owners still live in parts of the original house. A local historian told them that the site of the house was a Hessian stronghold. The bayonet and knife found in the wall of the house when it was restored, believed at first to be Hessian, were from a later period. Hessian and British soldiers were foraging for food there and in the surrounding area. How did the Mount Hope Hessians escape to Newark? This house and a few others were on Washington's route to Morristown. The deserters had to have help to hide, but nobody told tales. Washington rode down those roads on his way to Morristown to Mount Hope, stopping in what is today Ironia, Mount Freedom, Randolph, Denville and Rockaway, through the current German Club Germania Park, which is not far from the old ironworks.

9.

DESERTERS, LEGENDS AND THE RAMAPO MOUNTAIN PEOPLE

With a view and hope that men would desert that the Congress marched us at this inclement season; numbers answered their wishes, especially the Germans, who seeing in what a comfortable manner their countrymen live, left us in great numbers, as we marched through New York, the Jerseys and Pennsylvania; among the number of deserters is my servant.
—*Thomas Anburey,*. Travels through the Interior Parts of America, by Thomas Anburey, Lieutenant in the Army of General Burgoyne[117]

Hessian deserters, Native Americans, runaway slaves and prostitutes are said to be the ancestors of the reclusive Ramapo Mountain people, who have lived in Mahwah, New Jersey, since the American Revolution. They still suffer prejudicial treatment by surrounding communities and are called the "Jackson Whites" by some. Stories and tales of their unknown origins and different lifestyles have been appearing in newspapers and magazines since 1920. Local legends say that they are descended from the original native peoples living in the area, runaway Dutch slaves from the Newburgh area, Hessian deserters and three thousand prostitutes who fled from New York City when it was being burned during the Revolution. These ladies of the evening were said to have been brought into New York by a Captain Jackson, who lost one shipload at sea and went to Jamaica to pick up black women—therefore, some were Jackson Whites and others Jackson Blacks. Another story refers to the term "Jack" for a runaway slave; therefore, the mountain people were Jacks and Whites or Jackson Whites. There are local

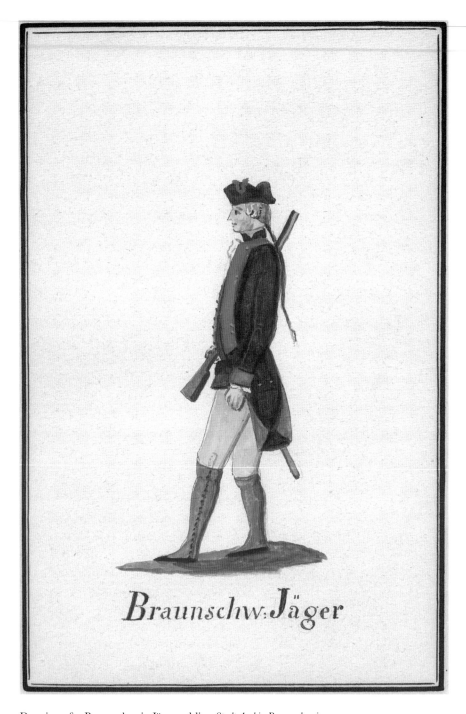

Drawing of a Braunschweig Jäger soldier. *Stadt Archiv Braunschweig.*

rumors about their supposed intermarriage, mentally challenged children, six fingers on each hand and albinos with blond hair, some of whom look "Black" or have dark skin.

There may be a kernel of truth in legends, but these tales are too unusual to be true and may have been created to promote prejudice and encourage hatred. The first problem is the name "Jackson White," a potato heavily advertised in the farm sections of nineteenth-century newspapers. It was the best one for planting and harvesting; when cooked, it turned from brown to white. The first newspaper story of "Jackson White" as a person does not appear until 1920. Is the source of this name to be found somewhere other than in the ranks of prostitution? Was there really a Captain Jackson commissioned by the British to bring women to Loyalist New York? Colonial prostitution thrived during the British occupation before and during the Revolution. In the jargon of the time, any woman who had sex before marriage was called a "prostitute"; the modern term is applied to women who take money for sex. The women of the night in early New York, during British occupation and after the fire in 1776, congregated at Broad Street in Manhattan in temporary housing nicknamed "Canvas and Topsail Town" for the flimsy covering of emergency roofing material. They congregated there to provide "service" for the population of the seaport.[118] A Captain Nathan Jackson ran a sloop up the Hudson River to Kingston and Esopus Meadows, New York, in 1775 on a ship named the *Greyhound*. He could have transported some of the "ladies" north, but certainly not three thousand. Maybe this ship was the legend's source.

Leonard Lispenard owned the property in the lower New York area called Lispenard Meadows, the home of colonial prostitution, and he also owned land near the Longwood mines near the Ramapo Mountains. Lispenard was an alderman and lawyer in colonial New York who, with another lawyer, James Delancy, sold off property in the Ramapo Mountain area. Was there a connection to the migration of prostitutes northward? The Revolutionary War papers did not print that sort of information. Colonial New York had a population of thirty thousand on the eve of the Revolution,[119] and the British government seemed to close an eye to the existence of the brothels. Prostitution was legal then; only the attraction of the undesirable elements to the area was a concern. Lieutenant Isaac Bangs, in Washington's army in 1776, describes the red-light district, known then as "Holy Ground" because of its proximity to Trinity Church:

During the Course of the last Week I several times visited the Holy Ground, before described. When I visited them at first, I thought nothing could exceed them for impudence and immodesty; but I found the more I was acquainted with them the more they excelled in their Brutality. To mention the Particulars of their Behavior would so pollute the Paper I write upon that I must excuse myself.

The whole of my aim in visiting this Place at first was Curiosity, as was also that of the chief of Gentlemen that accompanied; & it seems Strange that any Man can so divest himself of Manhood as to desire intimate Connexion with these worse than brutal Creatures, yet it is not more strange than true that many of our Officers & Soldiers have been so imprudent as to follow them, notwithstanding the salutary advice of Friends, till the Fatal Disorder seized them & convinced them of their Error. I am informed that 40 Men of one Regt which last Sunday set off for Quebec were infected with that disorder.[120]

The other problem was the contraction of the "Fatal Disorder" (syphilis) by citizens and soldiers from the ladies, who may have contracted it from visiting sailors. When the American army later occupied Manhattan, George Washington and the other officers tried to keep the soldiers out of the district. The cause for the "supposed migration" to the mountains was the fire of 1776. On September 21, a blaze of unknown origin broke out on the west side of Manhattan Island, sending hundreds of people fleeing, including, according to legend, the prostitutes. Sociologist David Steven Cohen names the guardian of the gate to the red-light district as Jackson,[121] and according to *Rivington's New York Gazetteer* of December 3, 1779, the runaway women went to Hoosick Falls, New York. Therefore, there was an evacuation of the lower parts of the city. How much of the sparse information about it is attached to the legend is hard to interpret. Otto Mann, then president of the Stag Hill Civic League, in an interview printed in the *Bergen Historical Society: 1975 Annual*, dismisses the term "Jackson White" as applying to anyone in the area.[122] Since even the source of the naming of a Maine potato is impossible to find, so, too, is the origin of this term when applied to the mountain people. Most modern accounts, however, quote the story as truth, naming no primary source that would include the journey of three thousand prostitutes to the mountains.

The Native American background is more easily traced; the Tuscarora tribe appears to be the original dwellers. There are "Indian Burial Grounds" in the area and also the likely possibility that during the Revolutionary War,

after the Battle of Saratoga, the Native American scouts employed by the British could have run into these mountains. There is very strong Native American presence in the mountains from the late seventeenth century on; however, the strong Germanic occupants are less evident.

The mountain people were engaged in woodcutting and charcoal making, according to Otto Mann. Peter Hasenclever brought about five hundred German laborers to the area to work in his iron mining operations. There is no record of who they were, except for the fact that they were from the Ruhr Valley and Rhineland in Germany. They were Palatine immigrants; once here, many had to use their wages to pay off the debt of the cost of the journey, being indentured for the requisite number of years. Many of them were not happy or had simply come to the country to find a better life, as opposed to the sad times in many of the German states. Men deserted into the wilderness and disappeared. Hasenclever, who was regarded by some as an excellent businessman and by others as a shady character, advertised on Thursday, July 11, 1765, in the *Pennsylvania Gazette*:

> *Ringwood June 19, 1765*
> *Run away George Dannefelder, an indented Servant to Peter Hassenclever Esq; a Dane or Swede, about 5 Feet 6 Inches high, black Hair, swarthy Complexion, by Trade a Butcher; had on, when he went away, agrees Jacket, blue cloth Breeches, Ozenbrigs Shirt, and a very shabby Hat. He went away in Company with one John Christopher, a Fellow about 5 Feet 2 Inches high, and had on a greenish Jacket, dirty Leather Breeches, and a Hat. Dannfelder talks very bad English and Dutch. Whoever takes up said Runaways, and brings them to Martin Noll, Tavern keeper at the upper end of Second Street Philadelphia, shall have Ten Pounds for either with reasonable charges paid by George Bateman.*

The problems with the German workers continued, as Hasenclever advertised in the *New York Mercury* on September 30, 1765:

> *Runaway from Ringwood Iron Works, about 20th of August, a contracted Miner, named Christian Nestler; he went off in the Dress of a German Miner, is about 5 Feet high, of a brown complexion, and stoops as he walks. Whoever takes up the said Run-away, and will deliver him at Ringwood, or will secure him in any Gaol, shall receive a Reward of FIVE-POUNDS, and all reasonable charges paid by PETER HASSENCLEVER.*

The desertion continued into 1766, when an ad appeared in the *Pennsylvania Gazette* on June 12:

> *Run away from Ringwood Iron Works in East Jersey, on the 29th of May at Night, the following Miners, viz. Carl Bruderlin German, about six Feet high, Pock-marked, with sandy Hair, Henry Schaeffer, about five Feet six inches high, black Hair, dark Complexion, and 38 years old. Joseph Langwieder, about five Feet six inches high, bandy legged, about 36 years old. Matthis Ortman, five Feet six Inches high, yellowish Hair and 24 years old. Bartholemew Baum, much the same size, but with black Hair. Wilhelm Konig, about the same size, with whitish Hair. Simon Denck, with one Eye only, short Hair 25 Years old. Peter Hutschlar, about five Feet six Inches high, thin, with yellow Hair. John Durck, short and Pock-marked.—They are all Germans, and talk very little English. Had on when they went away, Soldiers Jackets, and carried with them their Miners Clothes, black, with red Cuffs; also Guns and Hangers. As these Men are still engaged by Contract to serve three Years and four Months, and have been brought from Europe at a very great expense; all Gentlemen, Well-wishers to their Country, are respectfully desired not to engage these People in their service, but to get them secured in any of His Majesty's Gaols. Five Pounds Reward is offered for any one secured, and if sent back to the Works, all Charges will be paid besides, by applying to John Ross Merchant in Philadelphia, or to the Subscriber at Ringwood. PETER HASSENCLEVER.*

These men could have deserted right into the nearby mountains and remained hidden for years. There is no record of Hasenclever ever finding them. The Germans could have started a community and intermarried with the Native Americans. The "Convention Army" of prisoners marched right through Ramapo Pass into the mountains, and they could have deserted as they marched through. The other Germans could have come from the Hessians captured at Trenton, who then joined the American army for promised rewards and, after marching to Pompton Plains, deserted into the mountains. Immigrants were clannish, and the German charcoal burners who preceded the Revolution would easily have accepted the "runaways." There was a price on any deserter's head by Hasenclever and, during the war, by the other German forces. The only deserters to be listed for the Pompton Plains area by the Braunschweig Regiment were Heinrich Mayer and Christian Müller.

A brace of Hessian pistols brought back from the American Revolution to Marburg. *Marburg Museum.*

The other Hessian troops in the area were prisoners captured from Rall's regiment, placed in the American army and marched to Pompton Plains. How many left or vanished is unknown.[123]

There is evidence found in the Ramapos of a "retreat" in a cave where Hessian boots were found. There is no doubt that these "mountain" people were of German descent; the idea that they changed their names for protection may explain the lack of written records. The settlers on Island Road in Mahwah, mostly Palatine Germans, are well documented in the church records; however, nothing in the old "church books" appears to exist for the mountain people, whose names Mann, De Freese and De Groat are common in the German communities. Researchers have placed these names in the Palatine area. Cohen writes of a strange dialect in this community that, phonetically written, resembles the Dutch language. In the eighteenth century, the Dutch language spilled over a flimsy border into German East Frisia, where a dialect remains today called Platt Deutsch. It is a Low German speech still used across north Germany. There are houses today on the Dutch border where a person can speak Dutch to his next-door neighbor, who answers in "Platt"—each is understood by the other. From a distance the "Ost Friesian" speech

sounds very much like English; the most common example is "Moin, Moin," meaning "good morning" or "good day." Could the language remain in the mountains of Ramapo? Could this dialect of Low German have passed down through the generations?

There is another possibility for the source of the name "Jackson Whites" that might be a stretch for the historian. If the Hessians from Trenton and other areas who disappeared into the mountains were from a Jäger unit, their German nickname could have been Jägds, or Yagds in English. The German and American colonial armies had camp followers, with records of transport showing as many as eighty women and children on each military transport to America. These women were often wives of soldiers or served more than one soldier in many ways. Colonel von Wurmb of the Jägers wrote to Friederich Cristian Arnold, Baron von Jungkehn, minister of state, complaining that there were too many women coming over on the recruit transports. "The nuisance increases from year to year."[124] The German word *weib* until the nineteenth century meant "woman," one of the common people or someone else's wife. Therefore, if the Jägers had "weibs" and their name was shortened, the resulting group of deserters and company could be called "Jagds und Weibs"—Jägers and wives—and, if overheard or mispronounced, could be "Jackson Whites."

There are those who claim that runaway slaves intermarried and intermingled with the Ramapo Mountain people. There are no records of such, and while slaves found a refuge in the British army, it was only a temporary respite from servitude. His Excellency Sir Henry Clinton, K.B., published a broadside, apparently to encourage slaves to run away; however, at this point, of the many who ran (more than five thousand), the governor insisted on return to their masters. It is called the *Phillipsburg Proclamation* because it was issued from Clinton's headquarters in Westchester, New York.

African Americans in New York State were enslaved to a Dutch population and spoke Dutch and little English. Some certainly did run into the mountains to avoid being sent back to their owners. No one knows if it was the Ramapo Mountains that hid them.

The Ramapo Mountain people are most certainly of German American descent. There has been an attempt to discredit their ancestry by attaching it to ethnic groups that have been traditionally denigrated at one time or another. The modern researcher has to question the veracity of this history, particularly when there are other small and reclusive communities in the

By His Excellency
Sir Henry Clinton, K.B.
General and Commander in Chief of all his Majesty's Forces,
within the
Colonies laying on the Atlantic Ocean, from Nova Scotia to Weſt-
Florida,
induſive, &c, &c.

Proclamation
Whereas the Enemy have adopted a practice of enrolling

NEGROES

Among the Troops; I do hereby give Notice, That all Negroes

taken in
Arms, or upon any Military Duty, ſhall be purchased for the
ſtated price; the
Money to be paid to the Captors.
But I do moſt ſtrictly forbid any Perſon ro ſell or claim Right over
any
NEGROE, the Property of a Rebel, who may take Refuge with
any part
Of this Army: And I do promiſe to every

NEGROE
Who ſhall deſert the Rebel Standard, full ſecurity to follow
within theſe
Lines, any Occupation that he ſhall think proper.

Given under my Hand at Headquarters, PHILLIPSBURGH,
the
30th. Day of June, 1779
H. CLINTON
By his Excellency's Command,
JOHN SMITH Secretary [125]

surrounding states. One small town in New York State, in the foothills of the Shawangunk Mountains, is an isolated and clannish community. The citizens are all related and boast of Native American origins and Revolutionary War soldiers in their backgrounds. Their ancestry is vague and passed down by word of mouth. One woman knows that there are colonial ancestors in her background and was told by her grandmother that there were Native Americans too. She resides on a historic mountain ridge where an extended family lives in one corner of a single group of houses and stays entirely to itself. Does this mean that there is something strange in this settlement? The supposed Jackson Whites were branded by newspaper articles in New York as a "strange mountain community."

10.

LEGENDS AND HEADLESS HESSIANS

When, lo! as they reached the mountain-side,
A wondrous portal opened wide,
As if a cavern was suddenly hollowed;
And the Piper advanced and the children followed,
And when all were in to the very last,
The door in the mountain-side shut fast.
—Robert Browning, "The Pied Piper of Hamelin: A Child's Story"

Many American folk tales and legends originated in foreign countries, were brought across the ocean by immigrants and became embedded in American lore. Shortly after the American Revolution, Jacob and Wilhelm Grimm, from Hesse in Hesse-Hanau, and later from Hesse-Cassel, recorded German folk stories and created a book of fairy tales from them. The brothers, who had studied at Marburg University, recorded local legends that have been adapted and repeated in films and novels for over two centuries. The tales themselves originated before the Grimm brothers found them, having been in Germany and, in this case, Hesse for a long time.

The sources of these stories are connected to American Hessian legends. Folklore has roots in the German countryside, where the Grimm brothers lived. The oral history of the "old" country grew into storytelling, which repeated the traditional folklore both to entertain and to warn children and others of dangers, real or imagined, lurking in the New World. The American Revolution produced stories about larger-than-life heroes whose

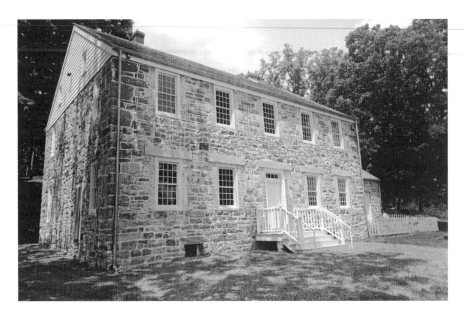

John Jacob Faesch House, Mount Hope, New Jersey. *Photo courtesy of the author.*

exploits grew into folk tales. For example, figures like George Washington, Molly Pitcher and Betsy Ross became the subjects of legends; the traditional exploits attributed to them were not always true. Little George Washington did not chop down the cherry tree and say, "I cannot tell a lie, I did it with my little hatchet." According to a fictionalized biography by Parson Weems, he did.[126] Was Molly Pitcher really Mary Ludwig Hays, or was she a composite of several women? Germans are great storytellers; some of the lore surrounding the German soldiers was passed down and embellished. There are connections, sometimes vague, to the legends surrounding the "Hessians" in New Jersey.

The first is the Pied Piper of Hamelin (Rattengfänger von Hamelin). The town of Hamelin, in Germany, employed a *Rattenfänger* (pied piper) to rid the town of rats. He played his pipes to entice the rats to follow him out of town to their deaths by drowning in the Weser River, never to be seen again. When he asked for the pay that he had been promised for this job, the mayor and the town officials refused. He put his pipes to his lips, but this time he led all the children of the town down the street, never to be seen again. The Grimm brothers in Hesse-Hanau heard these tales and transcribed them. The website for the town of Hamelin cites the year 1284 as the origin of the Pied Piper's tale, when the rats were part of the plague years. The children may have been the ones who left central Germany.[127] Among the various

interpretations, reference to the colonization of East Europe starting from Low Germany is the most plausible one. The "Children of Hamelin" could have been those citizens willing to emigrate, recruited by landowners, to settle in Moravia, East Prussia and Pomerania. Historically, Germans call local citizens "children of the town." The "legend of the children's Exodus" was later connected to the "legend of expelling the rats." This most certainly refers to the rat plagues being a great threat in the medieval milling town and to the more or less successful professional "rat catchers."

It might be a bit of a stretch, but the Ramapo Mountain people, and in fact other German deserters, may be connected to this legend based on disappearance into the mountains.

The Grimm brothers' story *"Schneewittchen und der Jäger,"* or "Snow White," is based on the life of Margarete von Waldeck, who was forced by her stepmother to move away to Wildungen in Brussels, where she fell in love with a prince (later Phillip II of Spain). She died mysteriously at the age of twenty-one, apparently poisoned; her father owned several copper mines, where workers died at a young age, having been employed as children. If they survived to adulthood, their growth was stunted; their work in the small mine shafts caused them to be deformed. They were called the "poor dwarfs" by townspeople. Could there be a connection to the tales of the "mysterious mountain people"?

The Grimm brothers published a second book, *Deutsche Sagen*, which was not as popular as the children's stories published a year earlier. This work was an attempt to catalogue German legends and mythical characters. Included are two folktales of a "headless horseman." One is set in Dresden, where a woman goes into the forest to gather acorns near the Lost Waters (Verlorenes Wasser) on the border of the Elbe Dresden Basin and hears a hunting horn. When she turns to look at the source of the sound, she sees a headless man in a long gray coat sitting on a gray horse. The other tale is set in Braunschweig, where a headless horseman called the "wild huntsman" blows a horn to warn hunters not to ride the next day, lest they meet a tragic accident.

There are two New Jersey "headless Hessian" stories. After the attack at the Battle of Red Bank on Fort Mercer, the wounded were taken to the Whitehall house for treatment and the dead were hastily buried on the banks of the Delaware River. A few years later, the winters and high water had worn away some of the embankment, exposing the bones of the earlier burials. The owner of the house, Ann Whitehall, was disturbed by fun-loving youths crossing the river from Philadelphia to reenact the battle of earlier years, using the newly unearthed cones as weapons. She directed her

sons to collect and re-bury the bones. They found two Hessians whose heads had been blown off; in their haste, they re-interred them but switched the heads, causing, according to local legend, the bodies to wander as ghosts at night searching for their lost parts.

Residents reported that their ghosts were seen wandering over the battlefield, trying to find each other and their proper head. They would fade in and out of the trees near the Delaware River until, in the twentieth century, they met near Crown Point Road, exchanged heads and turned into dust.[128]

The most famous headless horseman appears in Washington Irving's *The Legend of Sleepy Hollow* (1820). Gordon Thomas Ward, author of *Ghosts of Central Jersey: Historic Haunts of Somerset Hills*, believes that the "headless horseman of Sleepy Hollow, New York," is really the "Headless Hessian" of the Morristown Swamp. Irving chose the name Ichabod Crane for the central character who sees the horseman. Irving served in the New York militia in 1814 with the real Ichabod Crane, who served in the United States Army from 1813 to 1814 in New York. Crane was a colonel, and perhaps Irving had heard of him. However, there is a grave marker in the First Presbyterian churchyard in Morristown, New Jersey, for Sarah Crane. It has the following inscription on the bottom: "purchased by Ichabod Crane." Sarah Ross Crane was his mother. This Ichabod Crane, a farmer in Randolph, New Jersey, in 1817, was not connected to the colonel in New York. The Cranes were a large family spread out in New Jersey; one branch lived in the Morris Township–Randolph area into the twentieth century. All related that Jonathan Crane was the grandfather of the author Stephen Crane (*The Red Badge of Courage*) and the great-uncle of Ichabod Crane. The other Ichabod Crane, the colonel, was born in Elizabeth, New Jersey, and died and was buried in Staten Island. Washington Irving was influenced by one or maybe all of them, since Ichabod is an unusual, biblical name meaning "no glory" in Hebrew.

The name on the grave marker in Morristown was likely that of a friend of Irving's and a possible inspiration for the fictional character's name. The stone, designed by David Jefferies,[129] is reddish-brown with an angel's head carved on each side, floating on the top of the arched stone. Washington Irving saw this stone on a visit to Morristown while writing *The Legend of Sleepy Hollow*. He stayed in Morristown to write the *Life of George Washington* in 1853. The Morristown connection in the earlier part of the century is the Hone and Schermerhorn families of New York City and Acorn Hall. Irving's friends the Hones kept residence in New Jersey while living primarily

in New York City. Acorn Hall was a home owned by the Crane family in Morristown; it stayed in the Hone-Crane family into the twentieth century, when it was donated to the Morris County Historical Society. Augustus and Mary Crane built it in 1853 on the site of the Schermerhorn Farmhouse; Augustus Crane Hone was the son of the former governor of New York and president of the New York Stock Exchange. John Hone was a grandson of Commodore Matthew Perry and the grandnephew of one of the early mayors of New York. In 1915, John Hone was buried in Morristown in Evergreen Cemetery near Sarah Ross Crane. Washington Irving, the Hones and the Cranes traveled in the same social circle as the Astors, Roosevelts and many upper-class New Yorkers. John Hone and Phillip Hone, the mayor of New York, were members of the Mercantile Library Association. Both men were close friends of Irving's. Morristown was a respite and vacation spot for the rich and famous. It is fairly certain that Irving met or at least saw members of the Crane family. In the early 1820s, Irving studied German folktales for his book *Bracebridge Hall* (1822); this could be the connection to his headless horseman.

The story of the headless Hessian starts in Basking Ridge, near the famous (or infamous) White's Tavern. There, three horsemen of the Hessian forces were attacked in a skirmish with the Americans. One unfortunate soldier was decapitated by a cannonball, and legend says that the head was conscious enough to see the horse with his body ride off into Devil's Den in Morristown's great swamp. Twenty-first-century ghost hunters report that the "headless Hessian soldier" is still seen there.

Washington Irving's short story has become legend and the source of movies and television shows. It was written during the same era that gave birth to Frankenstein's monster, Robert Burns's "Tam O Shanter's Ride" and other gothic stories.

11.

GRAVES

During the American Revolution, the British and German dead were buried in unmarked graves. The officers' gravestones in the churchyards and fields have eroded or disappeared. Colonel Rall was buried in the First Presbyterian churchyard in Trenton, near where he died. After the stone vanished, a memorial was put in its place. General von Donop was laid to rest near the Whitehall House Red Bank Battlefield Park with his feet facing the river. The headstone is worn away.

Mass graves are often found during building construction or projects involving grading and digging. Eighteen graves were found in Carlstadt, New Jersey, with no markers. More are known to be in the churchyard of the Connecticut Farms Presbyterian Church in Union County; the most intriguing story is that of the Walton or Hessian Cemetery in Picatinny Arsenal. For years, the local Rockaway residents in Mount Hope and surrounding areas have referred to the graveyard as the "Hessian Cemetery." Local historians did not find a connection to Hessian soldiers except for their proximity to the Mount Hope ironworks. Only three of the graves are marked with a stone, but examination in the 1990s found graves marked with a stick protruding from the ground. Hessian troops foraged in the current Rockaway, Denville and Randolph areas of Morris County. Perhaps they were buried there or were from Faesch's ironworks down the road. When the Hessian workers of Faesch's forge were to be returned to their army, the officers found twenty-eight of the original thirty-five brought there. Three men who remained in New Jersey were

identified, but there were still a few missing. Had they died? Were they buried nearby? Did they desert? The answers are unclear.

The Old Barracks in Trenton has a Hessian ghost near the main fireplace where he was killed. He appears every Christmas on the anniversary of the Battle of Trenton. Is his spirit still restless? Are those of the Hessian bodies unearthed at Runnimede, New Jersey, and dumped into the Hudson River as a result of anti-German feelings during World War I? We will never know.

EPILOGUE

The stories and tales of the fate of the twelve thousand German soldiers who were killed, deserted or stayed behind after the American Revolution will remain shrouded by the clouds of historical tales. Their records and stories can be found in manuscripts and artifacts in various archives and museums. The smaller historical societies hold original documents that have not yet been catalogued or digitalized. There are forty-four historical organizations in Sussex County, New Jersey, and many more along the New Jersey paths of the Revolutionary War. The papers in German archives are either digitalized or well preserved, and they have survived two

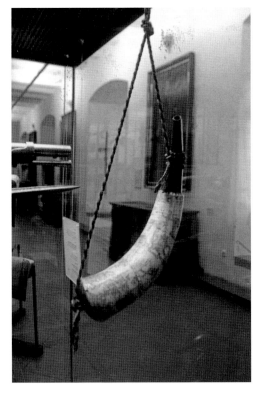

Hessian powder horn with scenes from the American Revolution. *Marburg Museum.*

world wars. They hold a font of information, much of it not translated or transcribed from the old German script or print.

The story of the American Revolution is a large part of the curriculum in American schools, as it once was. Sadly, the people of New Jersey are living on top of parts of American history, completely unaware of the lore of the land. Hopefully the increased interest in genealogy and history will, in turn, promote more interest in local historical societies and commissions, keeping the legends and the true history alive.

Appendix A

FILMS ABOUT THE AMERICAN REVOLUTION

All for Liberty. 2009. Starring Clarence Felder and Chris Weatherhead.

America. 1924. Starring Lionel Barrymore; directed by D.W. Griffith.

April Morning. 1987. Starring Chad Lowe, Tommy Lee Jones and Robert Urich.

Benedict Arnold: A Question of Honor. 2003. Starring Aidan Quinn and Kelsey Grammer; directed by Mikael Salomon.

Beyond the Mask. 2015. Starring Andrew Cheney, John Rhys-Davies and Kara Killmer; directed by Chad Burns.

Cardigan. 1922. Starring William Collier Jr., Betty Carpenter and Thomas Cummings; directed by John W. Noble.

The Crossing. 2000. Starring Jeff Daniels and Roger Rees; directed by Robert Harmon.

The Devil's Disciple. 1959. Starring Burt Lancaster, Kirk Douglas and Laurence Olivier; directed by Guy Hamilton.

The Devil's Disciple. 1987. Starring Patrick Stewart; directed by David Jones.

Drums Along the Mohawk. 1939. Starring Claudette Colbert and Henry Fonda; directed by John Ford.

The Howards of Virginia. 1940. Starring Cary Grant; directed by Frank Lloyd.

Independence. 1976. Narrated by E.G. Marshall and starring Eli Wallach, Pat Hingle, Ken Howard and Anne Jackson; directed by John Huston. Shown continuously at Philadelphia's Independence Visitor Center.

Johnny Tremain. 1957. Adaptation of the 1943 Esther Forbes novel starring Hal Stalmaster and Walter Coy; directed by Robert Stevenson.

John Paul Jones. 1959. Starring Robert Stack and Charles Coburn; directed by John Farrow.

La Fayette. 1961. Starring Pascal Audret, Jack Hawkins and Michel Le Royer; directed by Jean Dréville.

Mary Silliman's War. 1994. Starring Nancy Palk and Richard Donat; directed by Stephan Surjik.

The Patriot. 2000. Starring Mel Gibson and Heath Ledger; directed by Roland Emmerich.

The Rebels. 1979. Starring Andrew Stevens, Don Johnson and Doug McClure; directed by Russ Mayberry. Based on the novel by John Jakes.

Revolution. 1985. Starring Al Pacino; directed by Hugh Hudson.

The Scarlet Coat. 1955. Starring Cornell Wilde, Michael Wilding and George Sanders; directed by John Sturges.

Scouting for Washington. 1917. Edison Studios.

1776. 1972. Starring William Daniels, Howard Da Silva, Ken Howard, Donald Madden and John Cullum; directed by Peter H. Hunt.

1776, or The Hessian Renegades. 1909. Directed by D.W. Griffith.

Sons of Liberty. 1939. Starring Claude Rains and Gale Sondergaard; directed by Michael Curtiz.

Sons of Liberty. 2015. Starring Ben Barnes, Rafe Spall, Henry Thomas, Dean Norris and Jason O'Mara; directed by Kari Skogland.

The Spirit of '76. 1917. Starring Adda Gleason, Howard Gaye and Chief Dark Cloud; directed by Frank Montgomery. (Lost film; no surviving copies.)

Williamsburg: The Story of a Patriot. 1957. Shown continually at Colonial Williamsburg since 1957.

Appendix B
TREATY BETWEEN
HANAU AND GREAT BRITAIN

5 February 1776

Be it known to all whom it may concern, that his Majesty the King of Great Britain having judged proper to accept a body of infantry of the troops of his most serene highness the hereditary Prince of Hesse Cassell, reigning Count of Hanau, &c., to be employed in the service of Great Britain, the high contracting parties have giving orders for this purpose to their respective ministers, that is to say, his Britannic Majesty to Colonel William Faucitt, Captain of the guards; and the most serene hereditary Prince of Hesse Cassell to his minister and privy councillor Frederic de Malsbourg; who after the exchange of their respective full powers have agreed upon the following articles.

Art. I. The said Most Serene Prince yields to his Britannic Majesty a body of infantry of six hundred sixty-eight men, which shall be at the entire disposition of the King of Great Britain.

Art. II. The Most Serene Prince engages to equip compleatly this corps, and that it shall be ready to march the twentieth of the month of March next, at farthest. The said corps shall pass in review before his Britannic Majesty's commissary at Hanau, if that can be done, or at some other place, as opportunity shall offer.

Art. III. The Most Serene Prince engages to furnish the recruits annually necessary; these recruits shall be delivered to his Britannic Majesty's

commissary, disciplined and compleatly equipped: his Most Serene Highness will do his utmost that the whole may arrive at the place of their embarkation at the time his Majesty shall fix upon.

Art. IV. The service of his Britannic Majesty, and the preservation of the troops, requiring equally that the commanding officers and subalterns should be perfectly acquainted with the service, his Most Serene Highness will take proper care in the choice of them.

Art. V. The Most Serene Prince engages to put this corps on the best footing possible, and none shall be admitted into it but persons proper for campaign service, and acknowledged as such by his Britannic Majesty's commissary.

Art. VI. This corps shall be furnished with tents and all necessary equipage.

Art. VII. The King grants to this corps the ordinary and extraordinary pay, as well as all the advantages in forage, provisions, winter quarters, and refreshments, &c., &c., enjoyed by the royal troops; and the Most Serene Prince engages to let this corps enjoy all the emoluments of pay that his Britannic Majesty allows them. The sick and wounded of the said corps shall be taken care of in the King's hospitals, and shall be treated in this respect as his Britannic Majesty's troops; and the wounded, not in a condition to serve, shall be transported into Europe, and sent back into their own country at the expence of the King.

Art. VIII. There shall be paid to his Most Serene Highness, under the title of levy money, for each foot soldier, thirty crowns *banco*; the crown reckoned at fifty-three sols of Holland: one half of this levy money shall be paid six weeks after the signature of the treaty, and the other half, three months and a half after the signature.

Art. IX. According to custom, three wounded men shall be reckoned as one killed: a man killed, shall be paid for at the rate of the levy money. If it shall happen that any company of this corps should be entirely ruined or destroyed, the King will pay the expence of the necessary recruits to re-establish this corps.

Art. X. The Most Serene Prince reserves to himself the nomination to the vacant employments, as also the administration of justice. Moreover his Britannic

Majesty will cause orders to be given to the commander of the army in which this corps shall serve, not to exact of this corps any extraordinary services, or such as are beyond their proportion with the rest of the army; and when they shall serve with the English troops, or with other auxiliaries, the officers shall command (as the military service requires of itself) according to their military rank, and the seniority of their commissions, without making any distinction of what corps the troops may be with which they may serve. This corps shall take the oath of fidelity to his Britannic Majesty, without prejudice to that which they have taken to their sovereign.

Art. XI. Their pay shall commence fifteen days before the march of this body of troops, and from the time the troops shall have quitted their quarters, in order to repair to the place of their destination, all the expences of march and transport, as well as of the future return of the troops into their own country, shall be at the charge of his Britannic Majesty.

Art. XII. His Britannic Majesty will grant to the Most Serene Prince, during all the time that this body of troops shall be in the pay of his Majesty, an annual subsidy of twenty-five thousand and fifty crowns banco. His Majesty shall cause notice of the cessation of the afore said subsidy to be given, a whole year before it shall cease to be paid, provided that this notice shall not be given till after the return of the troops into the dominions of his Most Serene Highness.

This treaty shall be ratified by the high contracting parties, and the ratifications thereof shall be exchanged as soon as possible. In witness whereof, we the undersigned, in virtue of our full powers have signed the present treaty, and have thereunto put the seals of our arms.

Done at Hanau, the 5th of February, 1776.

[Signed] Frederic Bn. de Malsbourg. Signed: William Faucitt.

Appendix C

HESSIAN BATTLES IN NEW JERSEY

Iron Works Hill, December 22, 1776
Trenton, December 25–26, 1776
Assunpink Creek, January 2, 1777
Five Mile Run, January 1777
Millstone, January 20, 1777
Forage Wars, January–March 1777
Punk Hill, March 8, 1777
Bound Brook, April 12, 1777
Short Hills (Battle of Metuchen Meeting House), June 26, 1777
Battle of Red Bank, October 2, 1777
Springfield, June 7, 1780

Appendix D

OTTENDORF'S AMERICAN JÄGER COMPANIES

CAPTAIN ANTHONY SELIN'S COMPANY

Adler, Jeremiah (Jeremias) (Prinz Carl)

Donhemeyer (Danckemeyer), Frederick (Rhetz)

Hartmann, Peter (Barner)

Imhof (Imhoff), Frederick (Grenadier)

Lintz (Lentz, Linz), John (Erbprinz)

Miller (Moeller), Francis (Franz) (Prince Carl)

Myer (Meyer), Henry (Rhetz)

Riffert (Rueffer), Frederick (Artillery)

Shank (Scheneck), John (Erbprinz)

Albright (Albrecht), Jacob (Erbprinz)

Ebert (Albert), Henry (Barner)

Holzbery (Holzberg), John (Erbprinz)

Kholepp (Kohlepp), Casper (Erbprinz)

Lipehite (Leibheit), John (Specht)

Miller (Moeller), Phillip (Erbprinz)

Neider (Neiter), Henry (Erbprinz)

Schultz (Settler), Christian (Specht)

Sittler (Settler), Conrad (Grenadier)

CAPTAIN LAWRENCE OLIVIA'S COMPANY

Bottger (Boettcher), Andrew (Specht)

Kock (Koch), Henry (Specht)

Smith (Schmidt), Christian (Riedesel)

Bretbrenner (Bretbinder), Wilhelm (Retz)

Ricker (Ricke), Henry (Specht)

Swab (Schwab), Adam (Erbprinz)

Appendix D

CAPTAIN THOMAS PRY'S COMPANY
Horn, Christian (Specht)
Miller (Mueller), Christian (Barner)

CAPTAIN WILLIAM SATTERLEE'S COMPANY
Hairholt (Herhold), John (Grenadier)

CAPTAIN RICHARD LLOYD'S COMPANY
Huffman (Hoffman), George (Artillery)

LIEUTENANT ANDREW LEE'S COMPANY
Schewmiller (Shearmiller, Schweimeler), Philip (Riedesel)

NOTES

INTRODUCTION

1. Urquhart, *A History of the City of Newark*, vol. 2, 1044.
2. Jenny Sweetman, *New Jersey Herald*, March 15, 2015.

CHAPTER 1

3. Letter from Franklin to Peter Collinson, May 9, 1753.
4. *Trenton Evening Times*, March 28, 1905.
5. Machiavelli, *The Prince*.
6. *Boston News Letter*, August 2, 1720.
7. Ibid., September 18, 1721.
8. *The American Weekly Mercury*, May 21, 1830.
9. *Pennsylvania Gazette*, September 26, 1745.
10. Ibid., May 25, 1773.
11. Declaration of Independence.
12. Warren, *History of the Rise, Progress and Termination of the American Revolution*, 356–57.
13. Ramsey, *The History of the American Revolution*, vol. I, 327.
14. Bancroft, *History of the United States*, vol. 8, 271.
15. *New York Times*, July 14, 1860.
16. Trevelyan, *The American Revolution*, 35.

17. Ibid.

18. Robert Morris to the American commissioners in France, December 21, 1776.

19. Garraty and Carnes, *The American Nation: A History of the United States.*

20. Cayton, Winkler, Perry and Reed, *America Pathways to the Present.*

21. Davidson and Stoff, *American Nation*, 163.

22. Ibid., 171.

23. Conlin, *A History of the United States: Our Land Our Time*, 136–37.

24. Silent-ology: https://silentology.wordpress.com/2014/06/01/snoopathon-1776-or-the-hessian-renegade.

25. "Bunker Hill Bunny," copyright Warner Bros., directed by Fritz Freleng with Mel Blanc, 1950.

26. 2013 Fox Television.

Chapter 2

27. Beach and Rines, *Americana: A Universal Reference Library.*

Chapter 3

28. Lowell, *The Hessians*, 15.

29. Pausch, *Journal of Captain Pausch of the Hanau Artillery during the Burgoyne Campaign*, 2.

30. Ibid., 2.

31. Ibid., 8.

32. Atwood, *The Hessians*, 10.

33. Historical Manuscripts Commission: Report on American Manuscripts in the Royal Institution of Great Britain, vol. I, 42.

34. Ibid., 41.

35. Atwood, *The Hessians,* 15.

36. Ibid., 18.

37. Ibid.

38. Ibid., 20.

39. Riqueti, *Advice to the Hessians and Other Nations of Germany*, 12.

40. Ibid., 1.

41. Ibid., 12.

42. Lowell, *The Hessians*, 25.

43. Ibid., 26.

CHAPTER 4

44. www.digital history.uh.edu, *Royal Proclamation of Rebellion*, Digital History.
45. Lowell, *The Hessians*, 28.
46. *Parliamentary Register*, vol. V, 174–216.
47. Lowell, *The Hessians*, 32–33.
48. *The Declaration of Independence: A Transcription.*

CHAPTER 5

49. Lowell, *The Hessians*, 47.
50. Krebs, *A Generous and Merciful Enemy: Life for German Prisoners of War during the American Revolution*, 64.
51. Ibid.
52. Lowell, *The Hessians*, 47.
53. Seume, "In Hessian Lands," 1.
54. Ibid., 1.
55. Men were made to run down a line of the other soldiers in the company, who whipped the unfortunate as they passed by. The number of times the victim had to run was determined by either a court-martial or by a commanding officer.
56. Lowell, *The Hessians*, 46.
57. Historical Manuscripts Commission, 42.
58. Ibid., 41.
59. Lowell, *The Hessians*, 50.
60. Ibid., 47.
61. Ibid., 50.

CHAPTER 6

62. Stryker, *Battles of Trenton and Princeton.*
63. Tomlinson, *A Short History of the American Revolution*, 141.
64. Bancroft, *History of the United States*, 216.
65. Washington, *Papers.*

66. Lowell, *The Hessians,* 88.

67. Moran, "Colonel Johann Gottlieb Rall: Guilty of Tactical Negligence or Guiltless Circumstances?" 1.

68. Ibid.

69. Ibid.

70. Ibid.

71. Rizzo and McShulkis, "The Widow Who Saved a Revolution."

72. Ibid.

73. Ferris, "The Two Battles of Trenton."

74. Letter from Colonel Von Donop to Landgrave.

75. Ibid.

76. Court-martial of Colonel Rall.

77. Testimony of May 9, 1778, New Jersey Archives.

78. Testimony of May 11, 1778, p. 66, New Jersey Archives.

79. Ibid., 75.

80. Ibid.

81. Ibid., 76.

82. Pfister, *Die Amerikanische Revolution. 1775–1783, 41.*

Translation: Eine Stunde nach Tagesanbruch stießen die Spitzen der Amerikaner auf die Schildwachen der Hessische Billets Der Ruf: An die Gewehre wurde übertönt durch die ersten Schüsse und Salven. Trommeln und Hörner erschallten durch die Straßen von Trenton. Oberst Rall lag im Nachtshemd zum Fenster und schrie "Was ist denn los"? In einem Moment war Rall angezogen und stieg zu Pferde. ein Teil seines Regiments seines sammelte sich und Rall suchte sich einen Weg nach Princeton zu Bahnen.

Chapter 7

83. Riedesel, *Baroness von Riedesel and the American Revolution*, 148.

84. Ibid., 160.

85. Lowell, *The Hessians,* 124.

86. Riedesel, *Baroness von Riedesel and the American Revolution*, 4.

87. Lowell, *The Hessians,* 138.

88. Ibid., 142.

89. Ibid., 167.

90. Ibid.

91. Ibid., 169.

92. Letter from Feronce to Faucitt, Brunswick, December 23, 1777.

93. Anburey, *Travels through the Interior Parts of America*, 159.

94. Lowell, *The Hessians*, 184.

95. Maps from Marburg Archive, http://www.westjerseyhistory.org/maps/revwarmaps/hessianmaps.

96. Miles, "The German Soldiers of Pompton."

97. Lowell, *The Hessians*, 184.

98. Mellick, *The Story of an Old Farm, or Life in New Jersey in the Eighteenth Century*.

99. "Custer Monument at West Point. Formal Unveiling of the Statue. Oration by General Banks."

100. Letter from Major General von Riedesel to General George Washington, February 16, 1779 .

101. Brodie, *Thomas Jefferson: An Intimate History*, 183.

CHAPTER 8

102. *Jersey Journal*, July 30, 1884.

103. *Rivington's New York Gazetteer*, Issue 42.

104. *New York Journal*, June 26, 1867.

105. To George Washington from Richard Henry Lee, April 16, 1777.

106. From George Washington to Richard Henry Lee, April 24–26, 1777.

107. Original letters in the Morristown Library Historical Collection.

108. Miles, "The Iron Master and the Hessians."

109. *Trenton State Gazette*, Friday, August 25, 1871.

110. Drake, *History of Morris County*.

111. Miles, "The Iron Master and the Hessians," 17.

112. Ibid., 18.

113. *Boston Evening Transcript*, April 1864.

114. Miles, "German Soldiers of Pompton," 8.

115. Ibid., 23.

116. Ibid., 28.

CHAPTER 9

117. Anburey, *Travels through the Interior Parts of America*.

118. Gilfoyle, *City of Eros: New York City Prostitution and the Commercialism of Sex, 1790–1920*, 23.

119. Ibid.

120. Bangs, *Journal of Lieutenant Isaac Bangs, 1776*, 30.

121. Cohen, *The Ramapo Mountain People*, 17.

122. Tholl, *The Original Inhabitants of Bergen County and the Ramapo Mountain People*, 45.

123. For a list of Hessian soldiers in Pompton Lakes and the Ramapo Mountain area, see Appendix D.

124. Kipping, *The Hessian View of America*, 7.

125. *Colonel Beverly Robinson's Loyal American Regiment 1777–1783*, www.loyalamericanregiment.org/docs/Negroes.pdf.

Chapter 10

126. Weems, *The Life of Washington*.

127. www.hameln.com.

128. Story of the Headless Hessian. Author Unknown. Gloucester County, New Jersey History and Genealogy, http://www.nj.searchroots.com/Gloucesterco/hessian.html.

129. Watters, *Journal of the Association for Gravestone Studies*.

BIBLIOGRAPHY

Anburey, Thomas. *Travels through the Interior Parts of America, by Thomas Anburey, Lieutenant in the Army of General Burgoyne; with a Foreword by Major-General William Harding Carter.* 2 vols. Boston: Houghton Mifflin, 1923.

Andrews, Melodie. "Myrmidons from Abroad: The Role of the German Mercenary in the Coming of American Independence." Doctoral dissertation, University of Houston. Microfilms, 1986.

Atwood, Rodney. *The Hessians: Mercenaries from Hessen-Kassel in the American Revolution.* New York: Cambridge University Press, 2002.

Bancroft, George. *History of the United States from the Discovery of the American Continent.* 10 vols. (1834–1874). Boston: Little Brown and Co., 1861.

Bangs, Lieutenant Isaac. *The Journal of Lieutenant Isaac Bangs, April 1 to July 29 1776.* Edited by Edward Bangs. Cambridge: John Wilson and Son, 1890.

Banks, Nathaniel B. "Custer Monument at West Point. Formal Unveiling of the Statue. Oration by General Banks." *Boston Journal* XLVI (September 1, 1879).

Beach, Frederick, and George Rines. *The Americana: A Universal Reference Library.* New York: The Americana Company, 1911.

Brodie, Fawn. *Thomas Jefferson: An Intimate History.* New York. W.W. Norton, 1974.

Brown, Charles Brockden. *Wieland lor the Transformation: An American Tale.* New York: Hafner, 1967.

The Brunswickers in Nord Amerika 1779–1780. Stadt Archiv. Wolfenbüttel. 38 E Alt Nr. 260.

Cayton, Andrew, Allan Winkler, Elisabeth Perry and Linda Reed. *America: Pathways to the Present.* Upper Saddle River, NJ: Prentice Hall, 2005.

Clayton, W. Woodford, ed. *Union and Middlesex Counties, New Jersey, with Biographical Sketches of Many of Their Pioneers and Prominent Men*. Illustrated. Philadelphia: Everts and Peck, 1882.

Cohen, David Steven. *The Ramapo Mountain People*. Photography by Robert Goldstein. 4th ed. New Brunswick, NJ: Rutgers University Press, 1974.

Collins, Vernon Ramsey, ed. *A Brief Narrative of the Ravages of the British and the Hessians at Princeton in 1776–1777: A Contemporary Account of the Battles of Trenton and Princeton*. Princeton, NJ: University Library, 1906.

Colonel Beverly Robinson's Loyal American Regiment 1777–1783. www. loyalamericanregiment.org/docs/Negroes.pdf.

Conlin, Joseph R. *A History of the United States: Our Land, Our Time*. San Diego: Coronado Publication, 1985.

Cooper, James Fenimore. *The Spy: A Tale of Neutral Ground*. New York: Hafner, 1960.

Cumming, William P., and Hugh F. Rankin. *The Fate of a Nation: The American Revolution through Contemporary Eyes*. London: Phaidon Press, 1975.

"Custer Monument at West Point. Formal Unveiling of the Statue. Oration by General Banks." August 30, 1879.

Danforth, George H. "The Rebel Earl." Doctoral dissertation. Columbia University, University Microfilm, 1955.

Davidson, James, and Michael Stoff. *American Nation*. Upper Saddle River, NJ, 2003.

Dohla, Johann Conrad. *A Hessian Diary of the American Revolution*. Translated and edited by Bruce E. Burgoyne. Norman: University of Oklahoma Press, 1990.

Drake, Edmund, et al. *History of Morris County, New Jersey*. New York: W.W. Munsell and Company, 1882.

Dwyer, William M. *The Day Is Ours! An Inside View of the Battle of Trenton and Princeton, November 1776–January 1777*. New Brunswick, NJ: Rutgers University Press, 1998.

Ferris, Frederick. "The Two Battles of Trenton." In *A History of Trenton: 1679–1929*, edited by Edwin Robert Walker et al. Princeton, NJ: Princeton University Press, 1929.

Fischer, David Hackett. *Washington's Crossing*. Oxford: Oxford University Press, 2004.

Garraty, John, and Mark Carnes. *The American Nation: A History of the United States*. New York: Pearson, 2012.

Gilbert, William S. "Memorandum Concerning the Characteristics of the Larger Mixed Blood Islands of the Eastern U.S." *Social Forces* (May 24, 1946).

Gilfoyle, Timothy J. *City of Eros: New York City Prostitution and the Commercialism of Sex, 1790–1920.* New York: Norton, 1992.

Greene, Carol Wehran. *The Ramapough Chronicles: A Thirty Year History of Mahwah, New Jersey and Its Surrounds. The Story of an Early American Meetinghouse and the Hamlet that Grew Around It.* Mahwah, NJ: Carol W. Greene Publisher, 2009.

Greene, Florence. "Tobacco Road of the North." *American Mercury* 53 (July 1941).

Grimm, Brothers. *Grimm's Complete Fairy Tales.* New York: Barnes and Noble, 2009.

Grimm, Brüder. *Deutsche Sagen.* Stuttgart: Phillip Reclam, 1961.

———. *Kinder und Hausmärchen.* Band I. Märchen. Stuttgart: Phillip Reclam, 1980.

———. *Kinder und Hausmärchen.* Band 2. Stuttgart: Phillip Reclam, 1980.

Hall, Charles M. *The Atlantic Bridge to Germany. Vol. II Hessen Part A. Rheinland Pfalz Part B* (The Palatinate). Logan, UT: Everton Publishers Inc., 1976.

Harris, Mark. "America's Oldest Interracial Community." *Negro Digest* (July 6, 1948): 21–24.

Harte, Thomas. "Trends in Male Selection in a Tri-Racial Isolate." *Social Forces* 37 (March 1959).

Historical Manuscripts Commission. *Report on American Manuscripts in the Royal Institutions of Great Britain.* Vol. I. London: His Majesty's Stationary Office, 1901.

Hoffman, Elliott Wheelock. "The German Soldiers in the American Revolution." Vols. I and II. Doctoral dissertation, University of New Hampshire. University Microfilms, 1982.

Hume, Janice. *Popular Media and the American Revolution: Shaping Collective Memory.* New York: Routledge, 2014.

Kapp, Friedrich. *Der Soldatenhandel deutscher Fürsten nach Amerika: ein Beitrag zur Kulturgeschichte des achtzehnten Jahrhunderts.* Berlin: Springer Verlag, 1874.

Karels, Carol. *The Revolutionary War in Bergen County.* Charleston, SC: The History Press, 2007.

Kipping, Ernst. *The Hessian View of America: 1776–1783.* Monmouth Beech, NJ: Philip Freneau Press, 1971.

Knapper, George Edward. "The Convention Army, 1777–1783." Doctoral dissertation, University of Michigan. University Microfilm, 1954.

Krebs, Daniel. *A Generous and Merciful Enemy: Life for German Prisoners of War during the American Revolution.* Norman: University of Oklahoma Press, 2013.

Leiby, Adrian. *The Revolutionary War in the Hackensack Valley: The Jersey Dutch and the Neutral Ground, 1775–1783.* New Brunswick, NJ: Rutgers University Press, 1980.

Lowell, Edward J. *The Hessians and the Other German Auxiliaries of Great Britain in the Revolutionary War. With Maps and Plans*. New York: Harper Brothers, 1884.

Lubrecht, Peter T. *Germans in New Jersey: A History.* Charleston, SC: The History Press, 2013.

———. *New Jersey Butterfly Boys in the Civil War: The Hussars of the Union Army.* Charleston, SC: The History Press, 2011.

Machiavelli, Niccolo. *The Prince*. 1513. Reprint, New York: W.W. Norton, 1992.

Matloff, Maurice, general ed. *American Military History*. Army Historical Series. Washington, D.C.: Office of the Chief of Military History United States Army, 1973.

Mellick, Andrew D. *Hessians in New Jersey: Just a Little in Their Favor*. Newark, NJ: Newark Advertiser, 1888.

———. *The Story of an Old Farm, or Life in New Jersey in the Eighteenth Century.* Somerville, NJ: Unionist Gazette, 1889.

Miles, Lion G. "The German Soldiers of Pompton." *New Jersey Highlander* (Winter 1986).

———. "The Iron Master and the Hessians." *Journal of the Johannes Schwalm Historical Association* 2, no. 1 (1981).

Miles, Lion G., and James L. Kochan. *Guide to Hessian Documents of the American Revolution 1776–1783. Manuscripts and Translations from the Lidgerwood Collection at Morristown Historical National Par*k. Morristown, NJ: G.K. Hall and Co., 1989.

Moran, Donald L. "Colonel Johann Gottlieb Rall: Guilty of Tactical Negligence or Guiltless Circumstance?" *The Liberty Tree Newsletter* (November–December 2007).

Ozment, Steven. *Flesh and Spirit: Private Life in Early Modern Germany*. New York: Viking, 1999.

Pausch, Georg. *Journal of Captain Pausch of the Hanau Artillery during the Burgoyne Campaign*. Edited by William Stone. Albany, NY: Joel Munsell's Sons, 1886.

Pfister, Albert. *Die Amerikanische Revolution. 1775–1783, Entwicklungsgeschichte der Grundlagen zum Freistaat wie zum Weltreich. Unter Hervorhebung des deutschen Anteils. Für deutsche und amerikanische Volk geschrieben*. Erster uns Zweite Band. Stuttgart: J.G. Gotta'sche Buchhandlung Nachfolger, 1904.

Rae, Noel. *The People's War: Original Voices of the American Revolution*. Guilford, CT: Pequot Press, 2012.

Ramsey, David. *The History of the American Revolution*. 2 vols. Philadelphia: Aitken and Son, 1789.

————. *The History of the American Revolution.* 2 vols. Edited by Lester Cohen. Indianapolis, IN: Liberty Fund, 1990.

Riedesel, Baroness von. *Baroness von Riedesel and the American Revolution: Journal and Correspondence of a Tour of Duty, 1776–1783.* A revised translation with introduction by Marvin Brown Jr. Chapel Hill: University of North Carolina Press, 1965.

Riqueti, Honoré Gabriel. *Advice to the Hessians and Other Nations of Germany, Sold by Their Sovereigns to England.* Amsterdam, 1777.

Rizzo, Dennis, and Alicia McShalkis. "The Widow Who Saved a Revolution." *Garden State Legacy* 18 (2012).

Rosengarten, Joseph G. *A Defence of the Hessians.* Reprinted from *The Pennsylvania Magazine of History and Biography.* Philadelphia, 1899.

————. *The German Allied Troops in the North American War of Independence, 1776–1783. Translated and abridged from the German of Max Von Elking.* Albany, NY: Joel Munsell's and Sons, 1893.

————. *The German Soldier on the Wars of the United States.* 2nd ed., revised and enlarged. Philadelphia: J.B. Lippincott, 1890.

Sampson, Richard. *Escape in America: The British Convention Prisoners, 1777–1783.* Chippenham, UK: Picton Press, 1995.

Seidel, Jochen. *Juchhe nach Amerika! Der Einsatz fränkischer Truppen im Amerikanischen Unabhängigkeitskrieg.* http://ww.jochen-seidel.de/ab-troops/usa1777.htm.

Seume, Johann Gottfried. "In Hessian Lands." From *Aus Meinem Leben.* Reclam Taschenbuch Nr. 1060. Stuttgart: Reclam, 1991.

Sherman, Andrew M. *Historic Morristown, New Jersey: The Story of Its First Century.* Illustrated. Morristown, NJ: Howard Publishing Company, 1905.

Simpson, Erik. *Mercenaries in British and American Literature, 1790–1830: Writing, Fighting, and Marrying for Money.* Edinburgh, UK: Edinburgh University Press, 2010.

Slagle, Robert Oakley. "The Von Lossberg Regiment: A Chronicle of Hessian Participation in the American Revolution." Dissertation, American University. University Microfilms, 1965.

Smith, Clifford Neal. "German Mercenaries in the American Revolution." *National Genealogical Quarterly* (March 1977).

————. "Some German Prisoners of War in the American Revolution." *National Genealogical Society Quarterly* (June 1971).

Storms, James B.H. *A Jersey Dutch Vocabulary.* Park Ridge, NJ: Pascack Historical Society, 1964.

Storms, John C. "Origin of the Jackson Whites of the Ramapo Mountains." Typed manuscript, 1958.

Stryker, William. *Battles of Trenton and Princeton*. Boston: Houghton and Mifflin Company, 1898.

Tholl, Claire K. *The Original Inhabitants of Bergen County and the Ramapo Mountain People*. River Edge, NJ: Bergen County Historical Society, 1975.

Tomlinson, Everett. *A Short History of the American Revolution*. New York: Doubleday Page and Company, 1901.

Trenton Evening Times. "A Good Word for the Hessians: An Apologist Appears for the Hated Mercenaries of 1776." *New York Sun*, December 8, 1876.

Trevelyan, Sir George Otto. *The American Revolution*. 4 vols. New York: Longman and Green, 1903.

Tuttle-Hoff Papers. North Jersey History and Genealogy Center, the Morristown and Morris Township Library.

United States Department of State. *The Revolutionary Diplomatic Correspondence of the United States / Edited Under Direction of Congress by Francis Wharton, with Preliminary Index, and Notes Historical and Legal*. Published in conformity with act of Congress of August 13, 1888. Washington, D.C.: Government Printing Office, 1889.

Urquhart, Frank. *A History of the City of Newark: Embracing Practically Two and a Half Centuries, 1666–1913*. Vol. 2. New York: Lewis Historical Publishing Company, 1913.

Ward, Alexander James. *The Story of the Convention Army*. New York: New-York Historical Society, 1927.

Warren, Mrs. Mercy Otis. *History of the Rise, Progress and Termination of the American Revolution, Interspersed with Biographical, Political and Moral Observations, in Two Volumes*. Bedford, MA: Appleton Books, 1905.

Washington, George. *Papers*. The Library of Congress Collection, Washington, D.C.

Watters, David, ed. *Journal of the Association for Gravestone Studies*. Lanham, MD, 1987.

Weems, Parson Mason Locke. *The Life of Washington*. Mount Vernon, NY, 1809.

Wilhelmy, Jean-Pierre. *Soldiers for Sale: German Mercenaries with the British in Canada during the American Revolution*. Montreal: Baraka Books, 2011.

Wust, Klaus, and Heinz Moos. *Three Hundred Years of German Immigrants in North America, 1683–1983: In German and English (Dreihundert Jahre Deutsche Einwanderer in Nord Amerika)*. 2nd ed. Baltimore: Verlags GmnH, 1983.

INDEX

About the Author

Peter Lubrecht has a PhD in educational theater from New York University and a master's degree in English and drama from NYU's Graduate School of Art and Science. He is an adjunct professor of English at Berkeley College. He also taught at Northampton Community College; Lehman University Graduate School and Lincoln Center (Performing Arts in the English Classroom); Jersey City University; and Bergen, Morris and Passaic Community Colleges. He studied with the late Lowell Swortzell, the founder of the Educational Theatre Program at NYU, as well as with Nellie McCaslin, the creative dramatics pioneer, and the late Stephen Palestrant, noted theater historian and set designer.

He is the author of *New Jersey Butterfly Boys: The Third New Jersey Cavalry in the Civil War*, *Germans in New Jersey* and *Liebe Kück: A German Soldier's Story of the Great War*. He has traveled as a presenter to the University of Roehampton

in London, University of Portsmouth, Southern Utah University, Wartburg College, Iowa and his alma mater, New York University, for international Shakespeare conferences. He has been lecturing locally on the Civil War, German American history, genealogy and nineteenth-century American theater. He founded Community Theatre at Brundage Park Playhouse in Randolph, New Jersey.

You can find him on his website: www.olpeteshistoryalive.com.